THE GOONIES™

The Official Coloring Book

Illustrations by **VALENTIN RAMON**

INSIGHT EDITIONS

San Rafael · Los Angeles · London

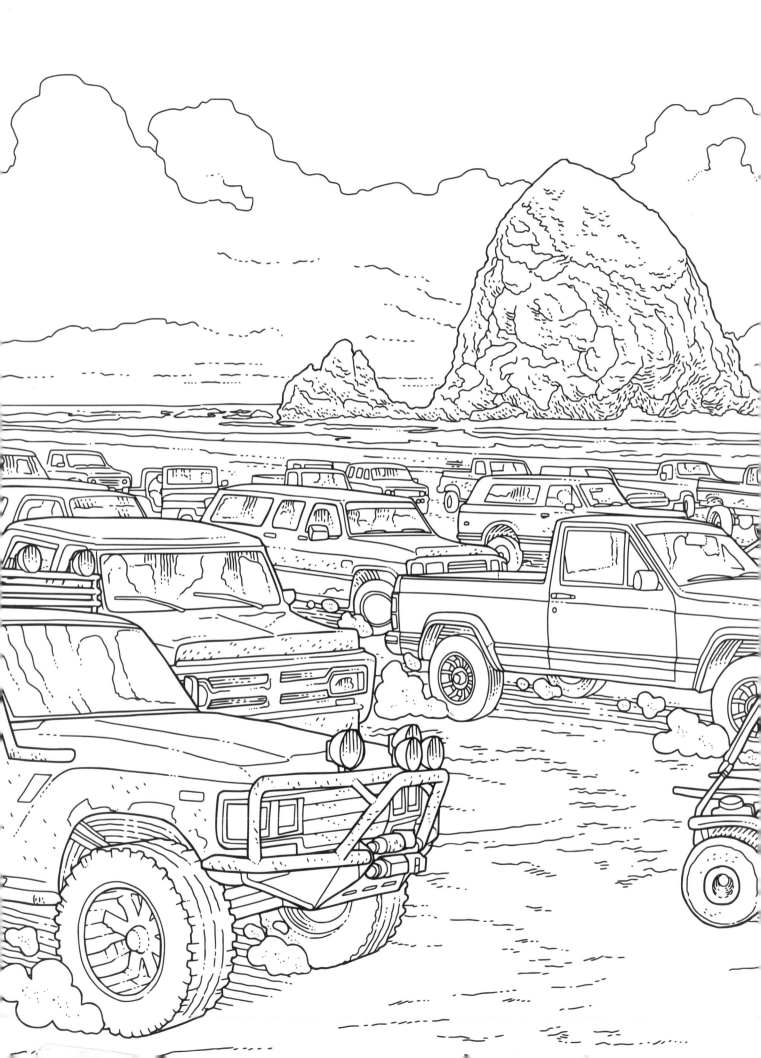

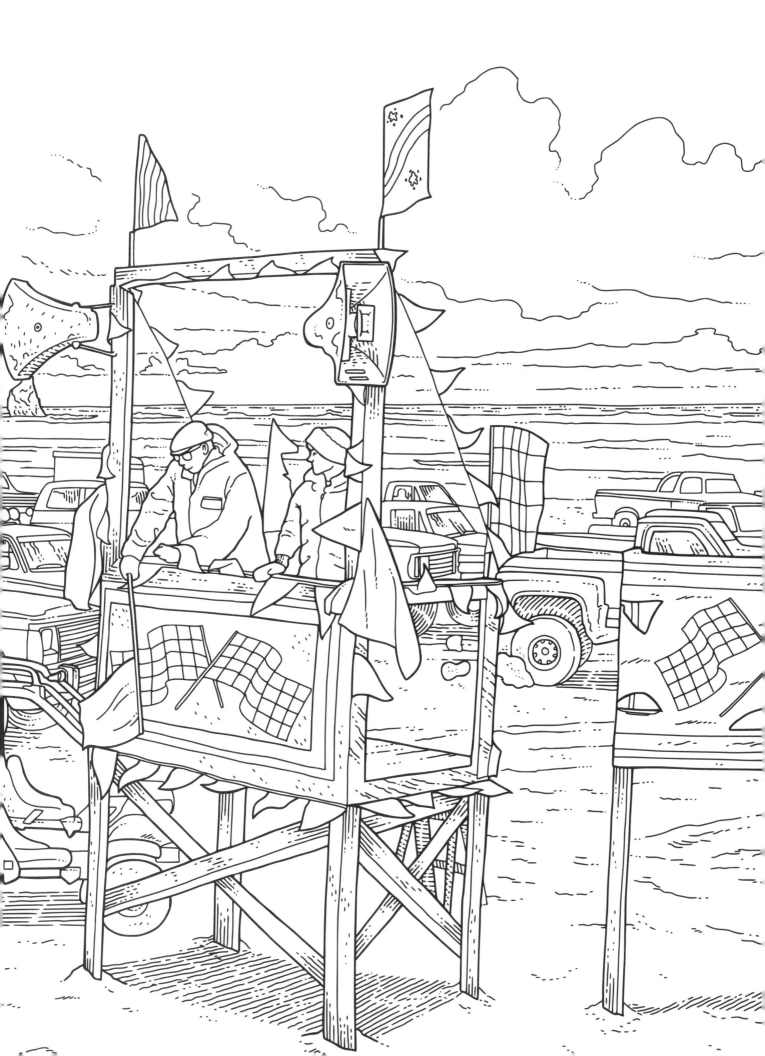

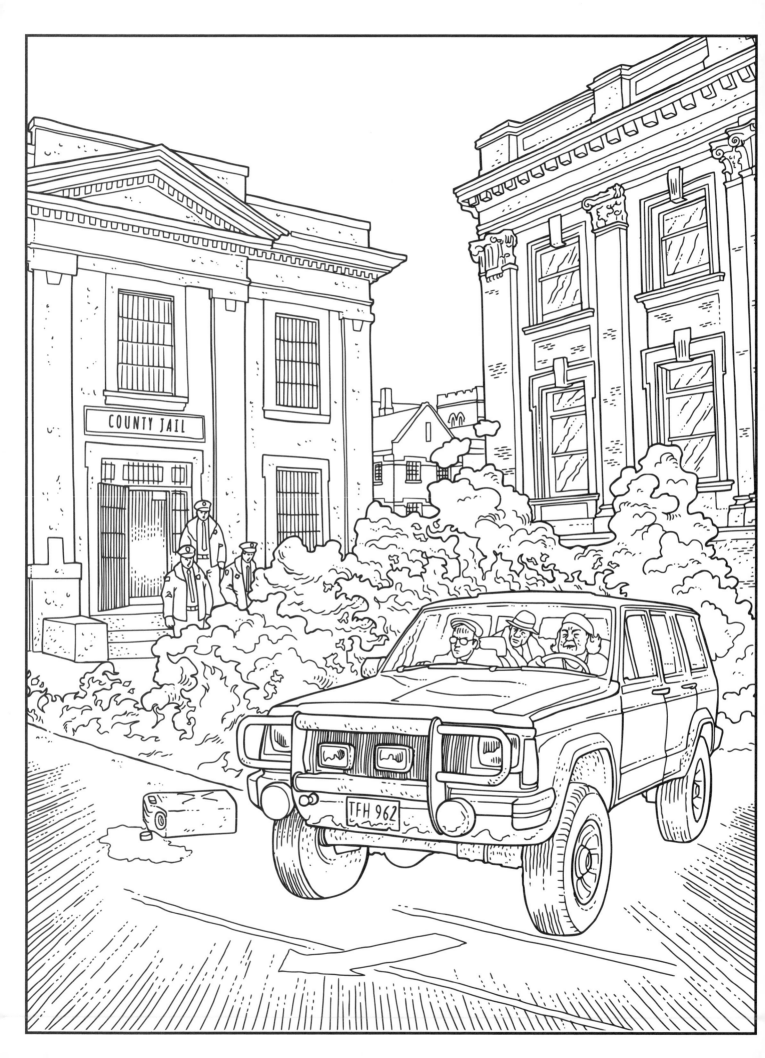

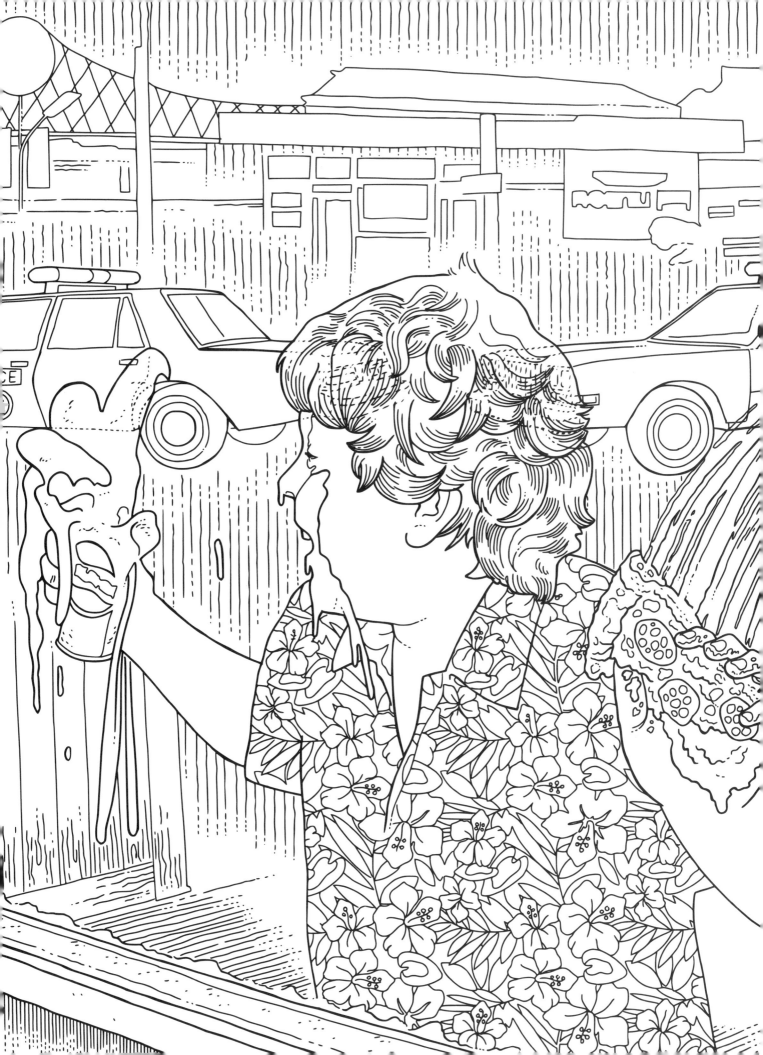

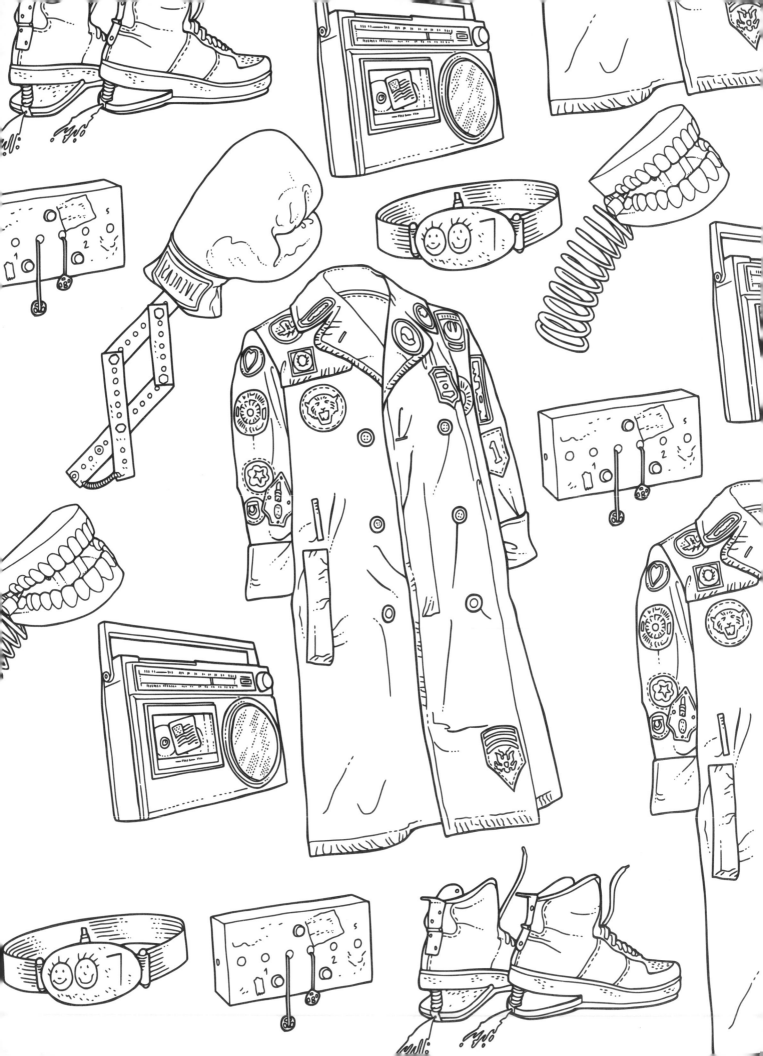

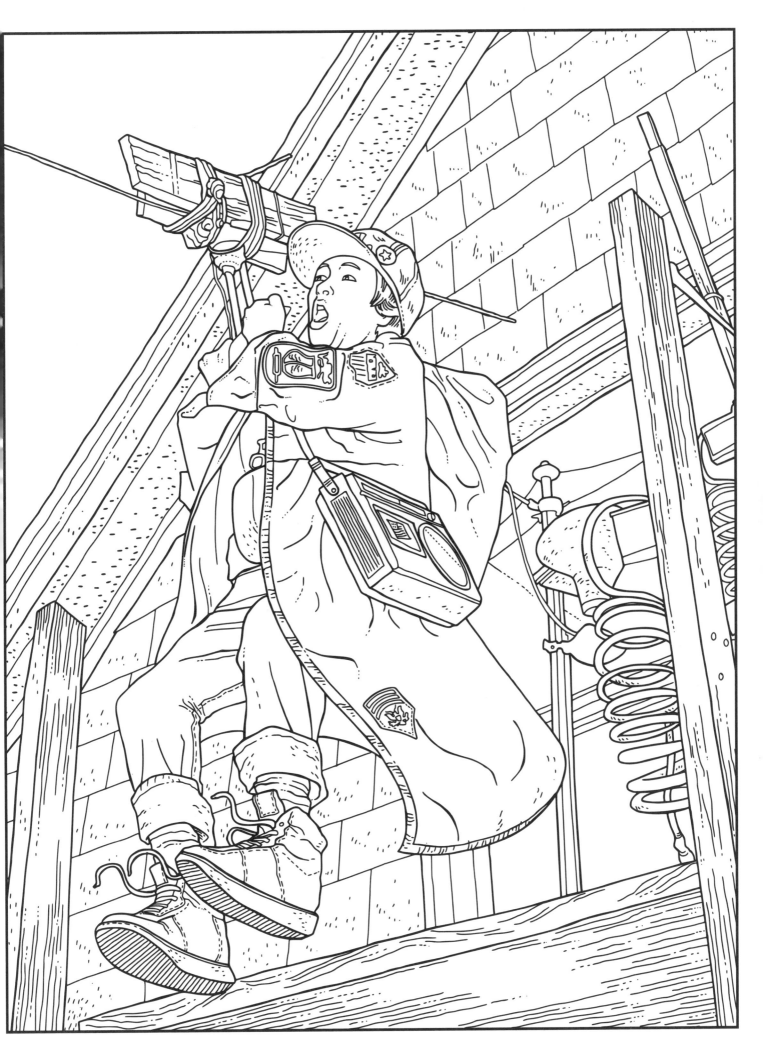

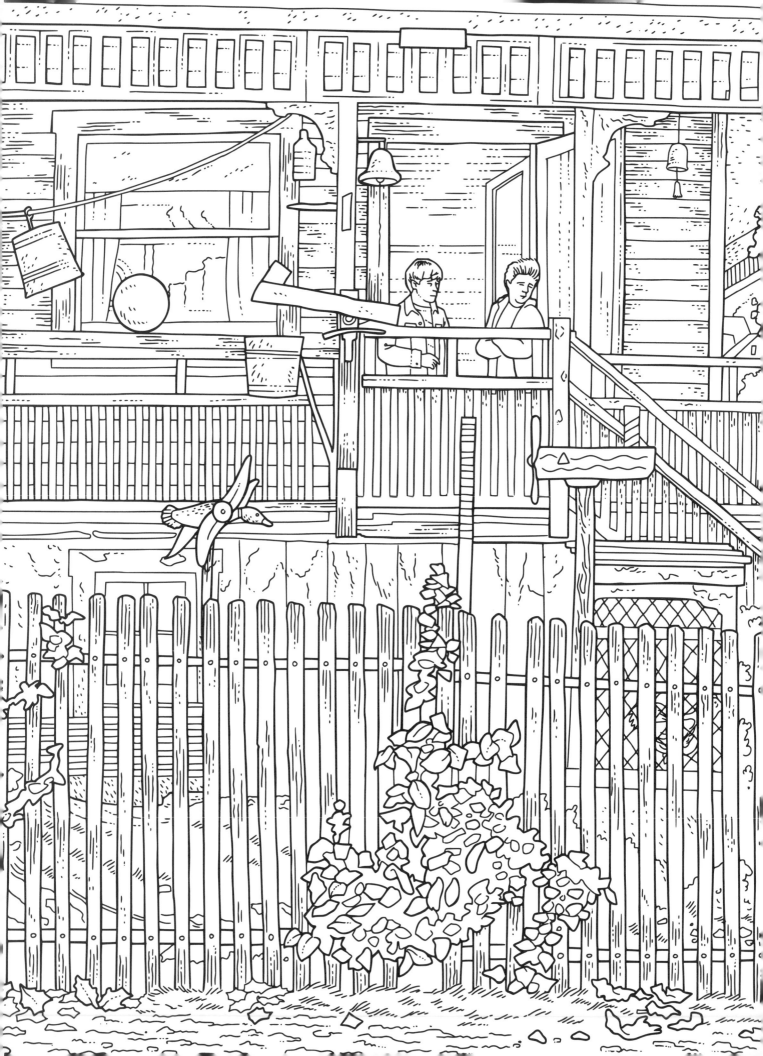

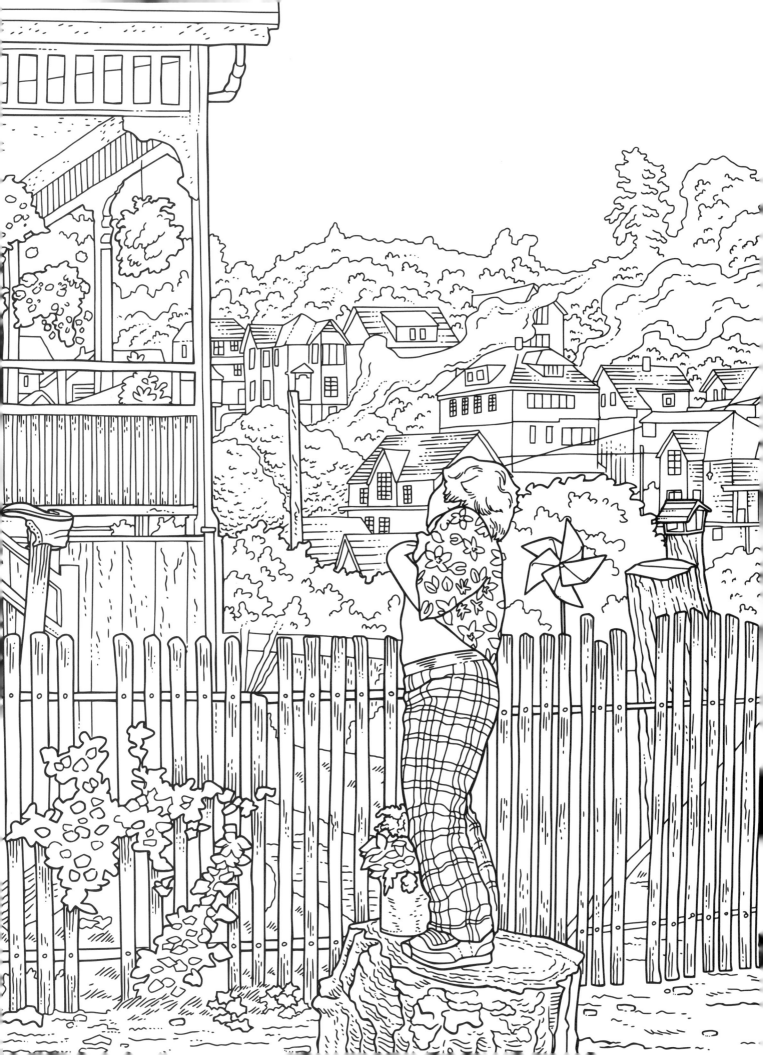

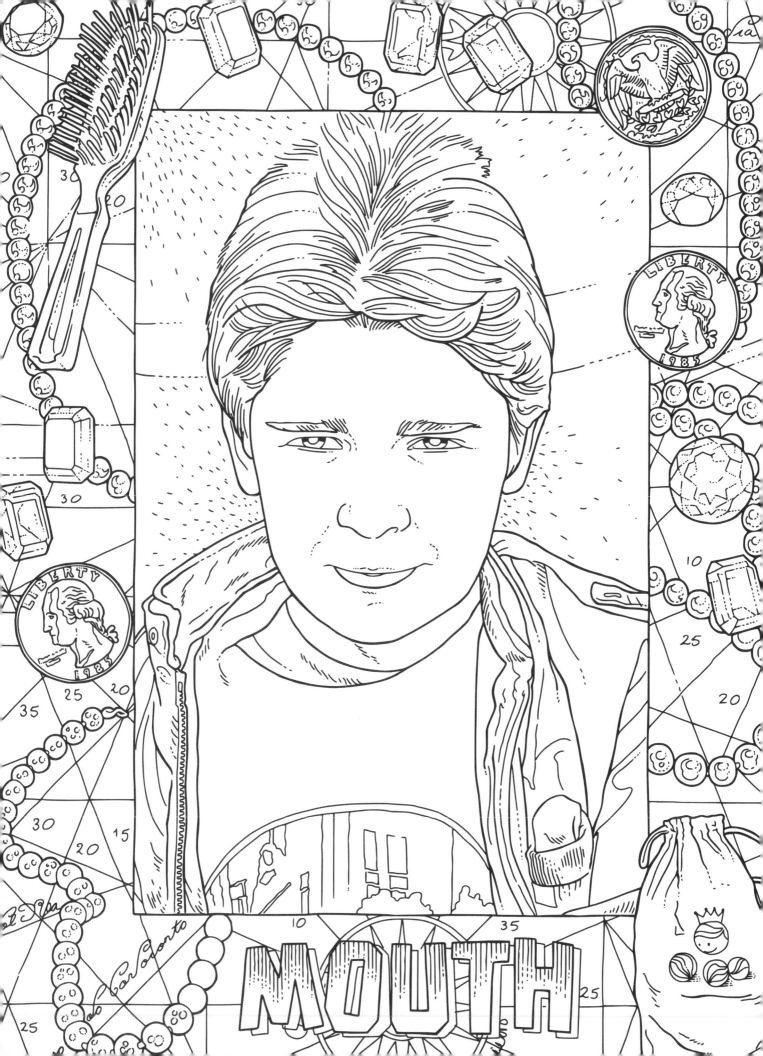

MOUTH

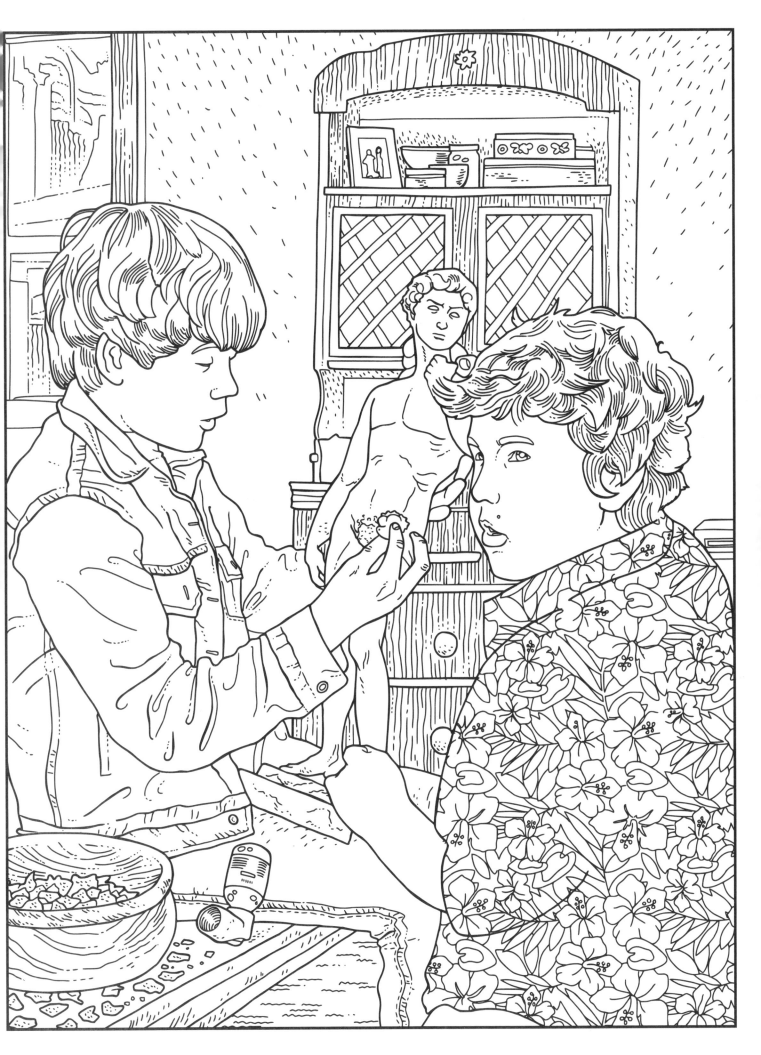

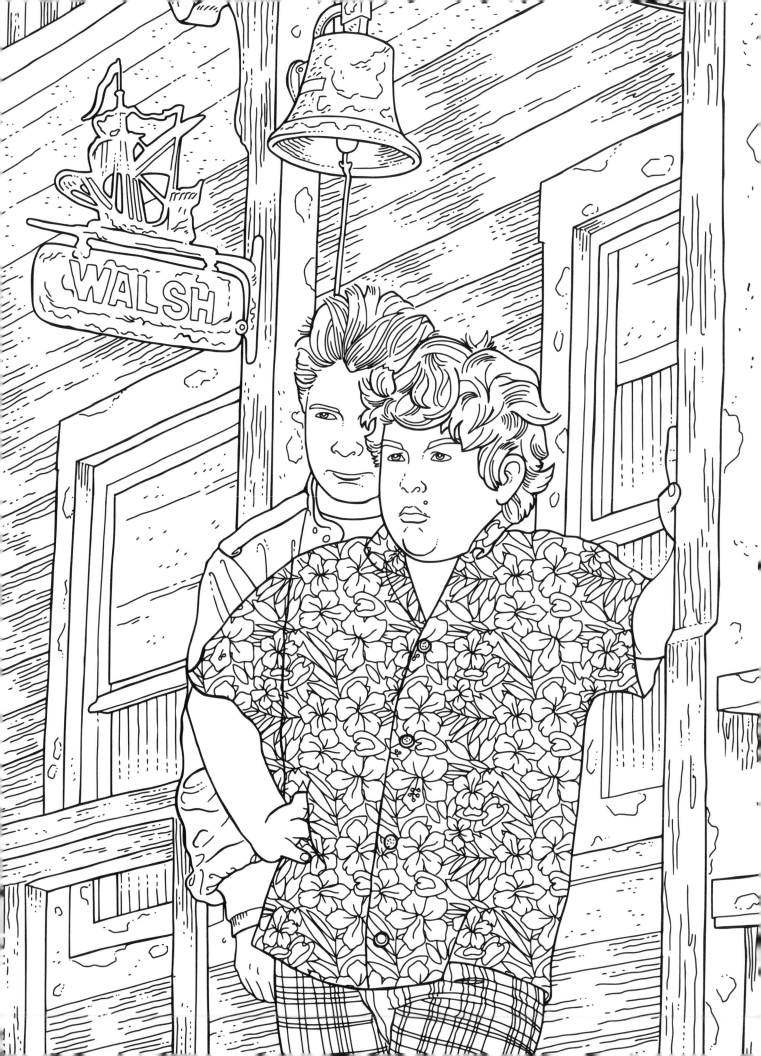

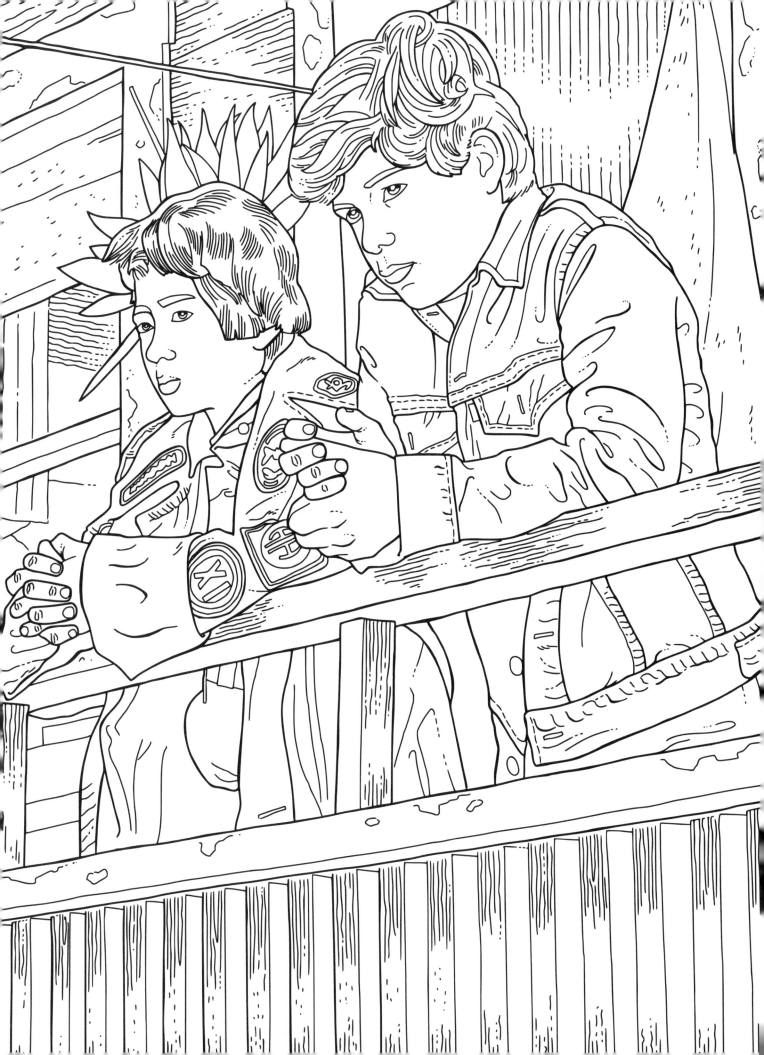

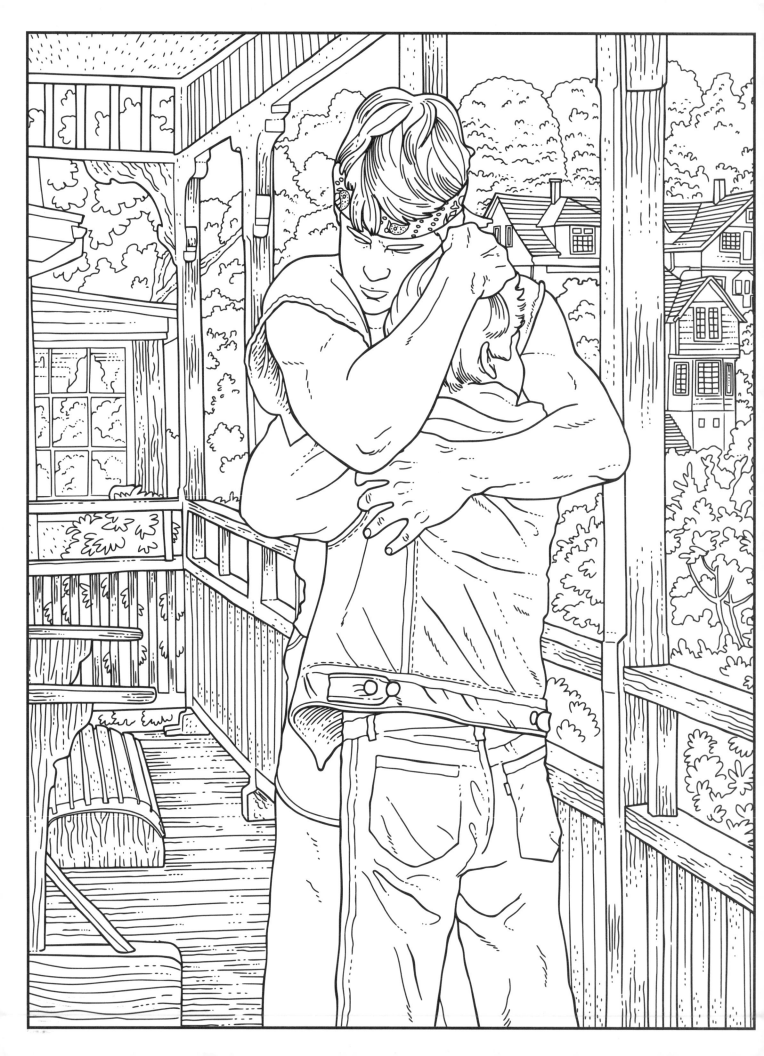

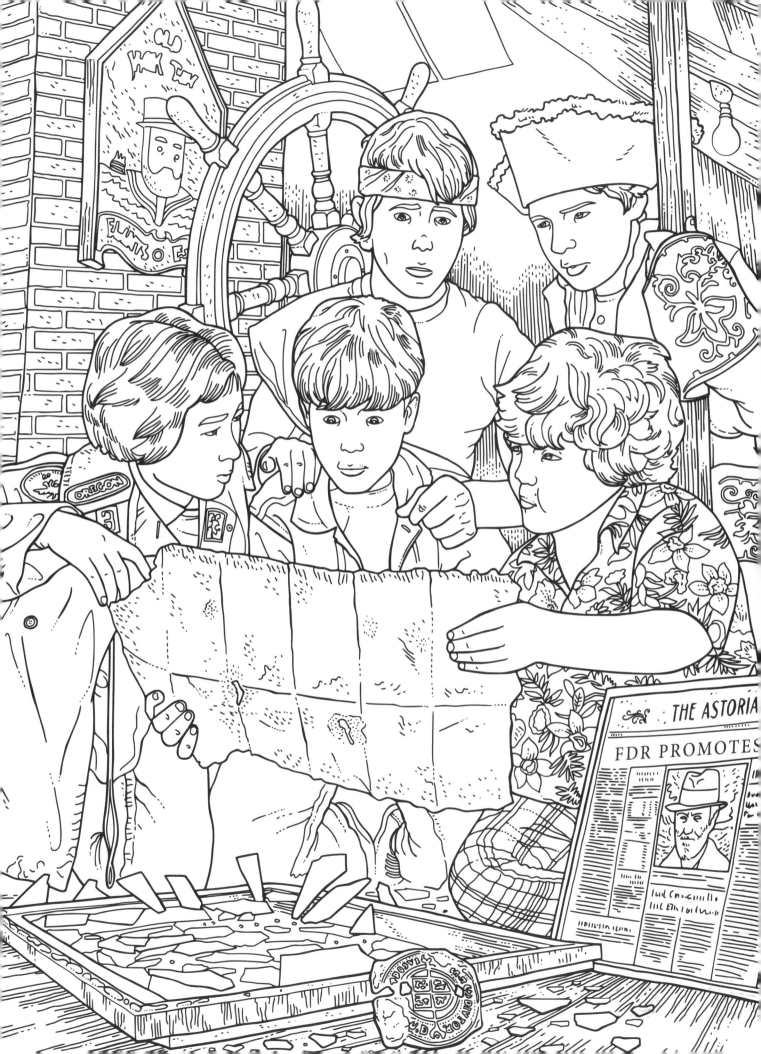

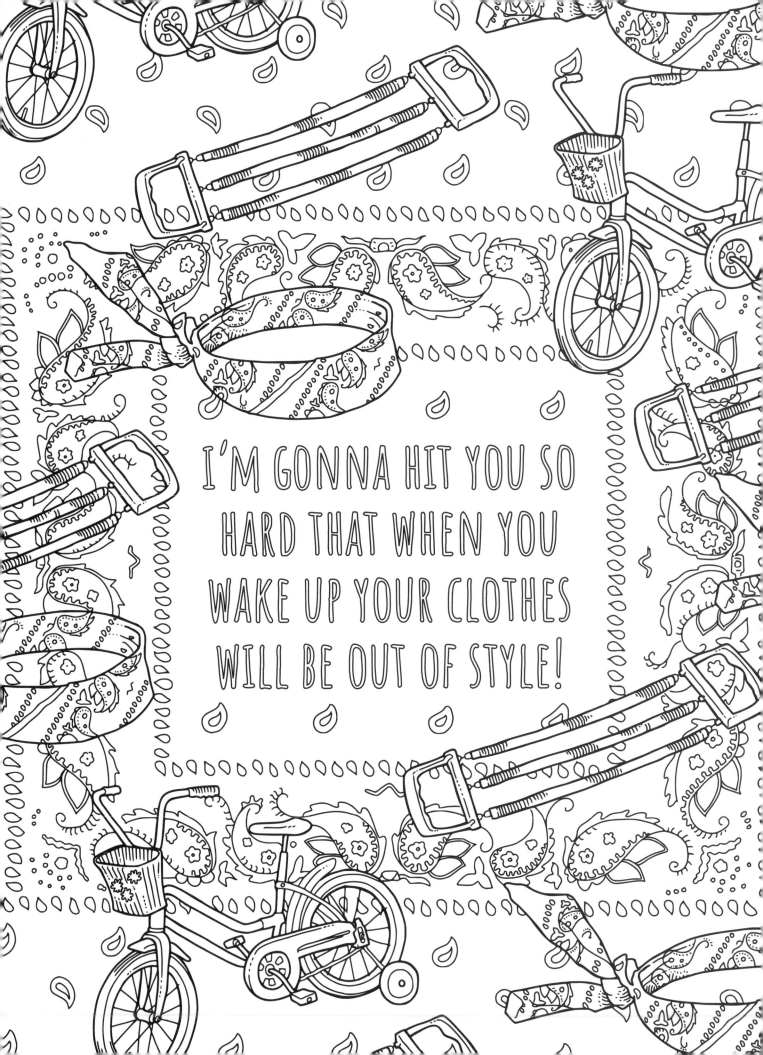

I'M GONNA HIT YOU SO HARD THAT WHEN YOU WAKE UP YOUR CLOTHES WILL BE OUT OF STYLE!

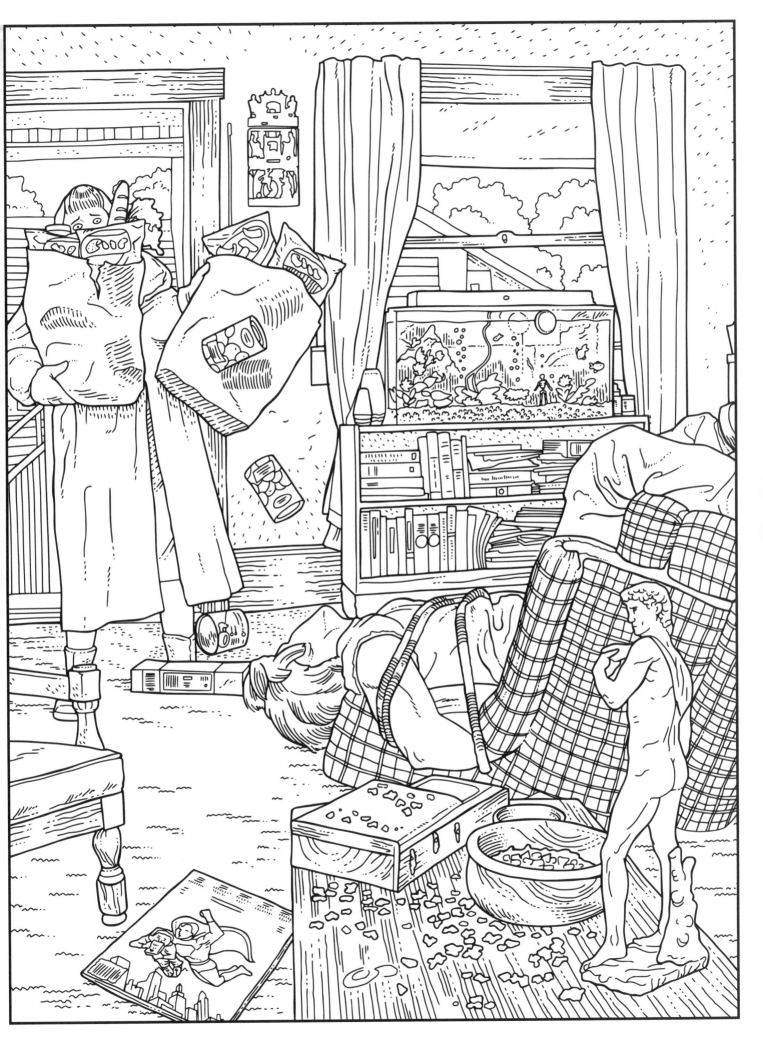

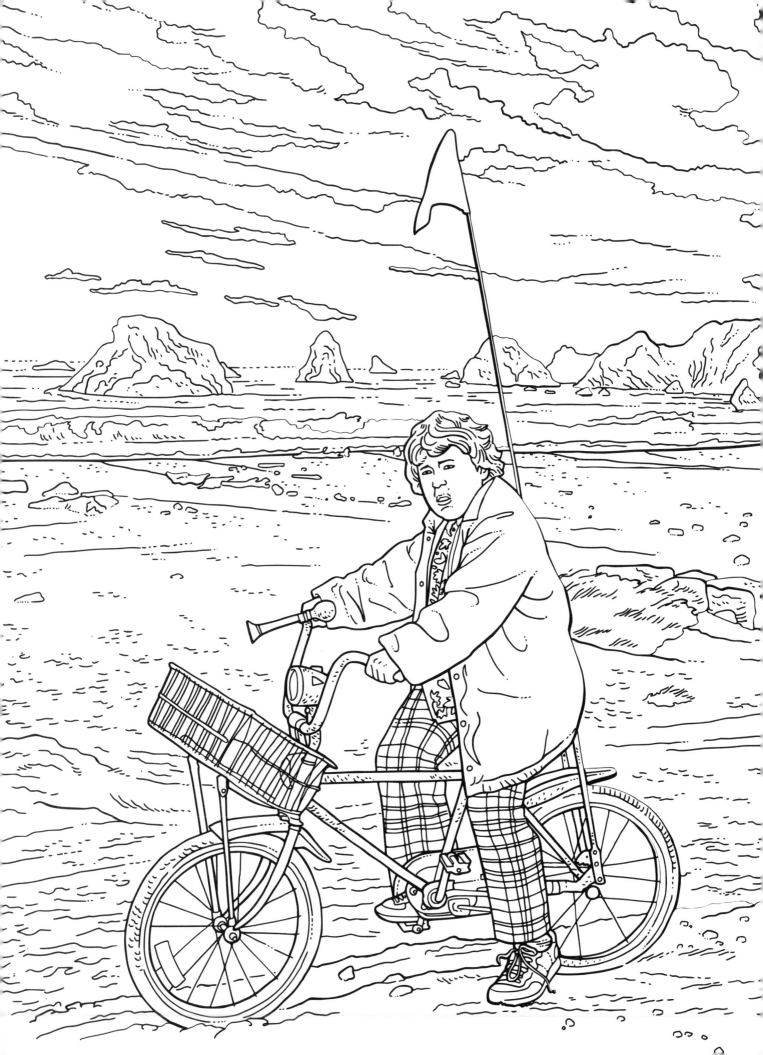

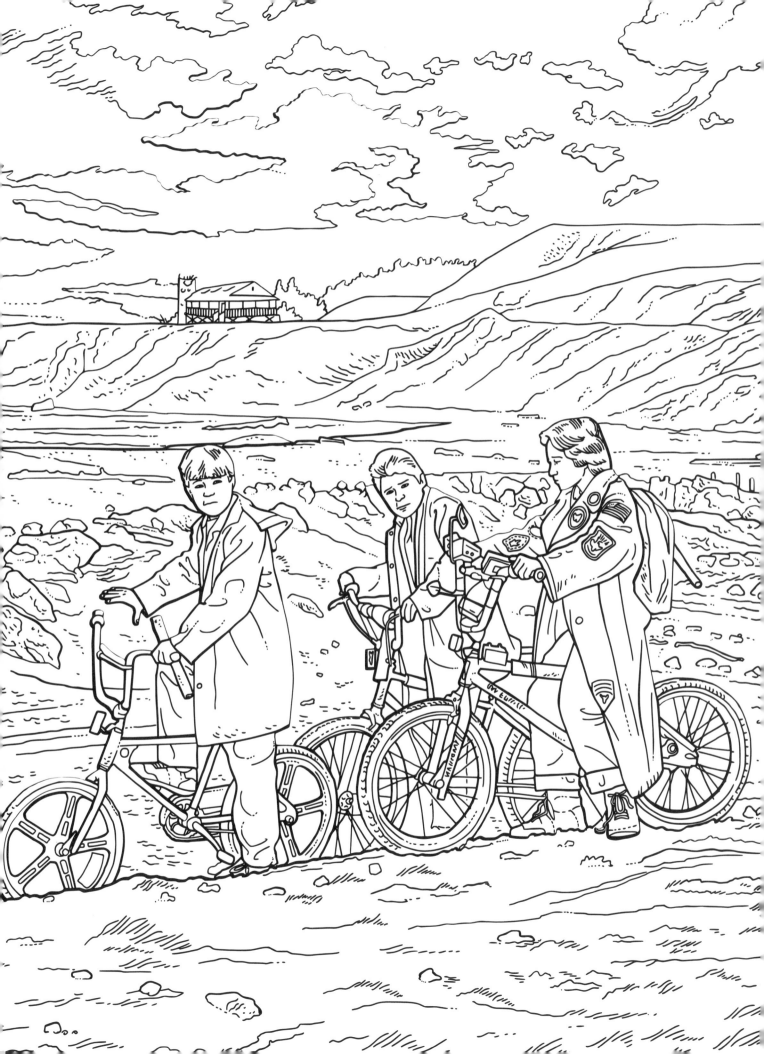

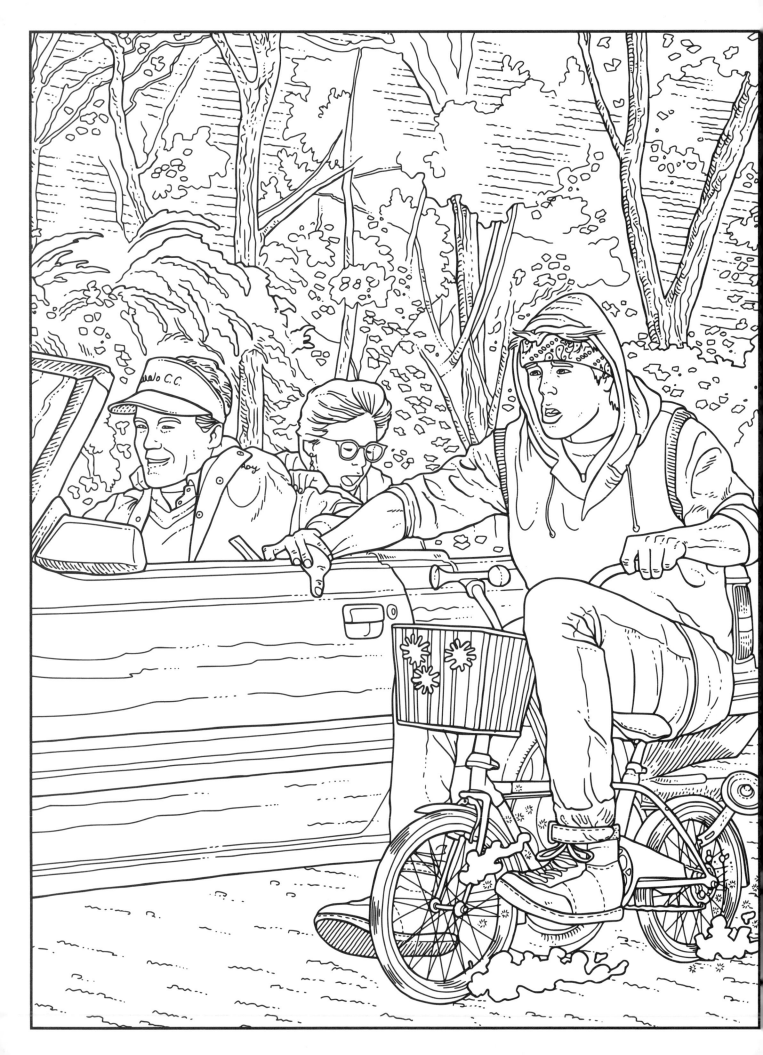

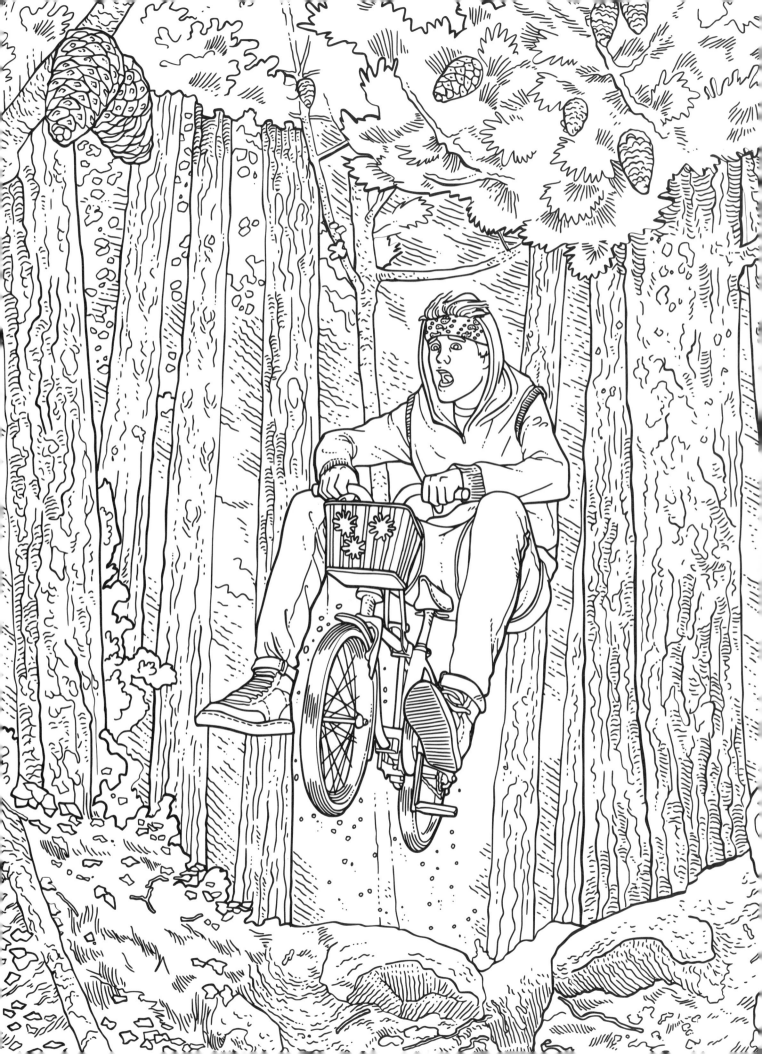

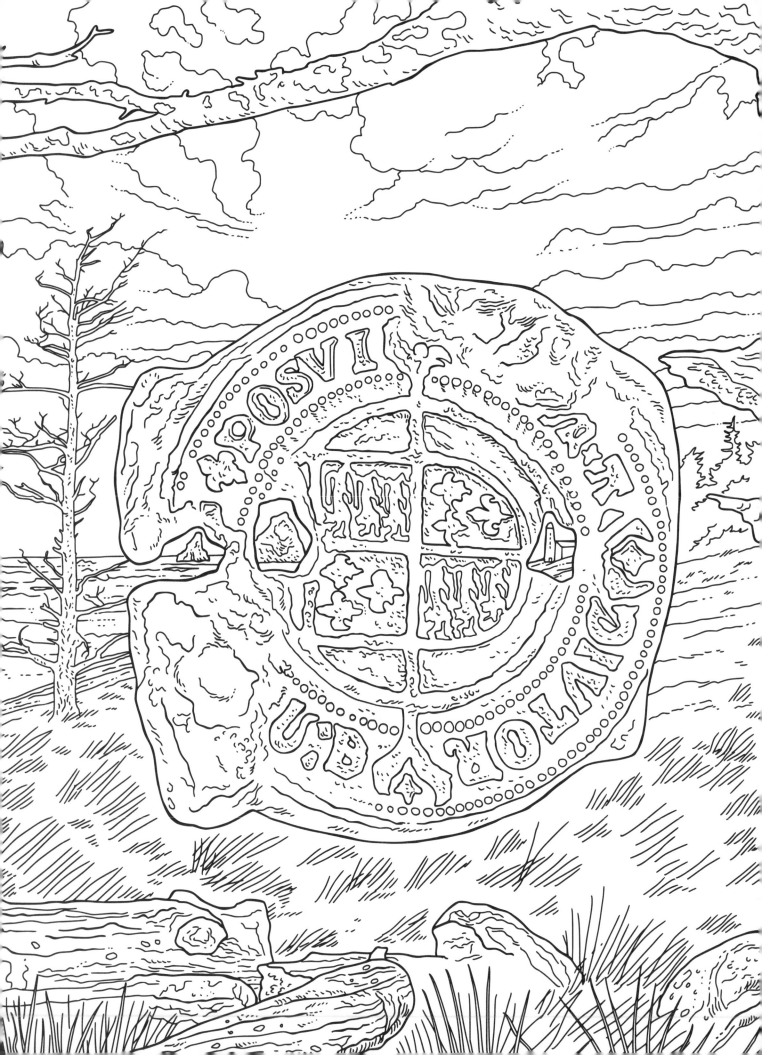

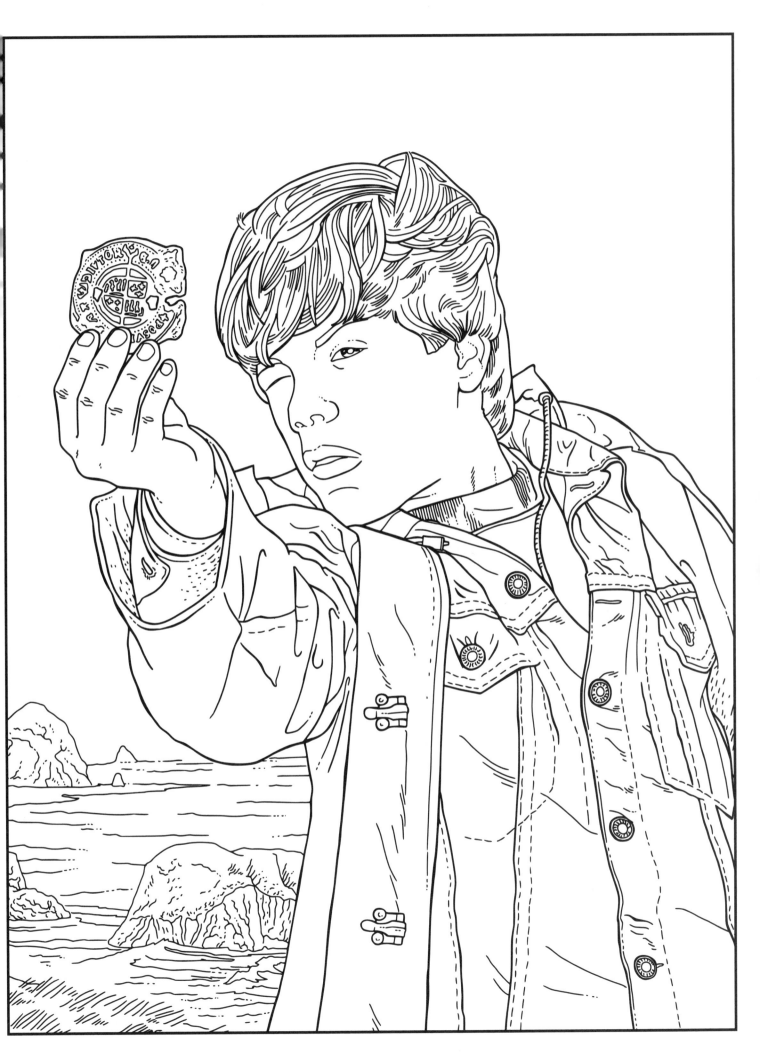

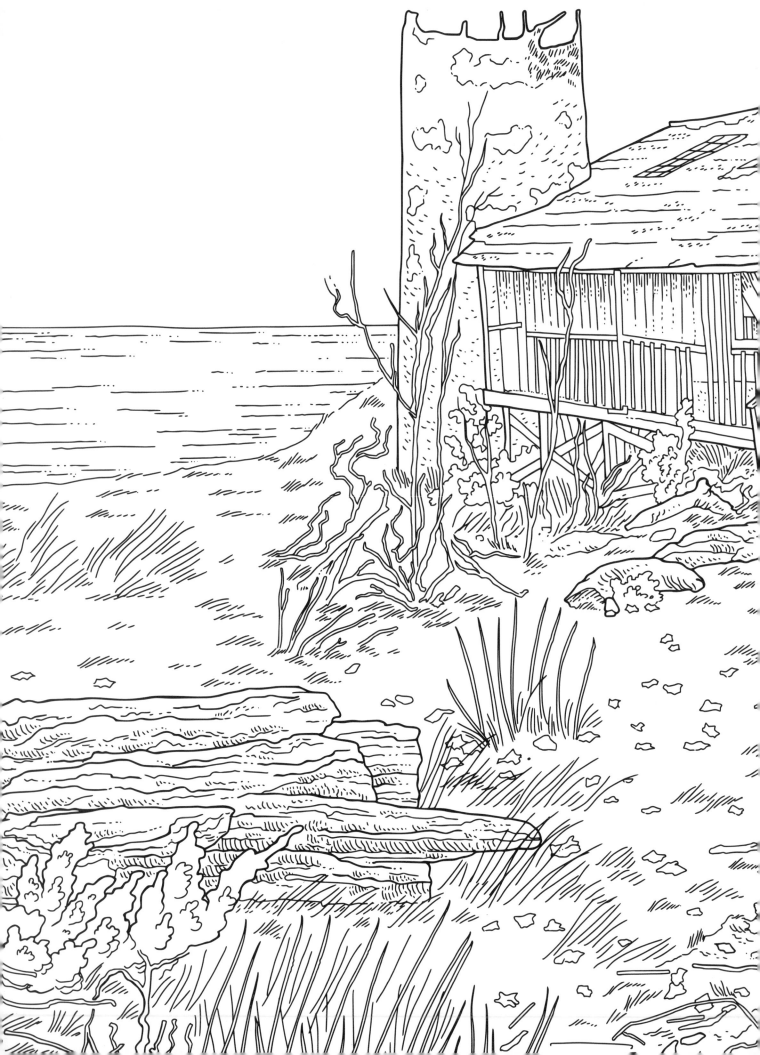

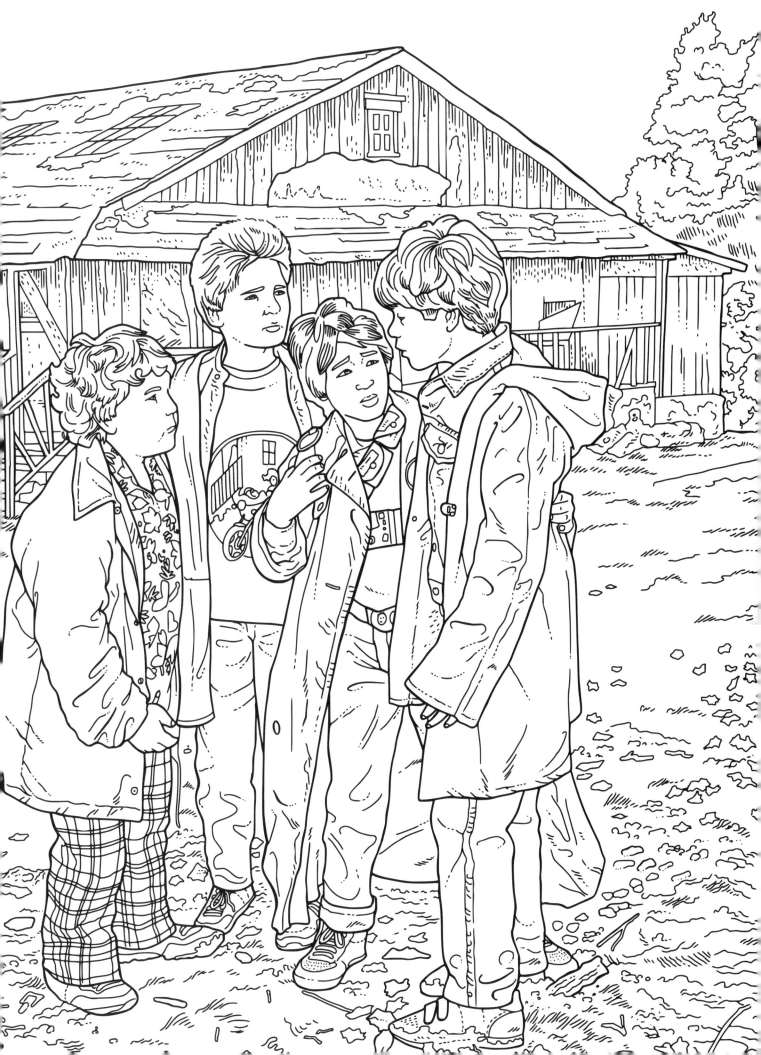

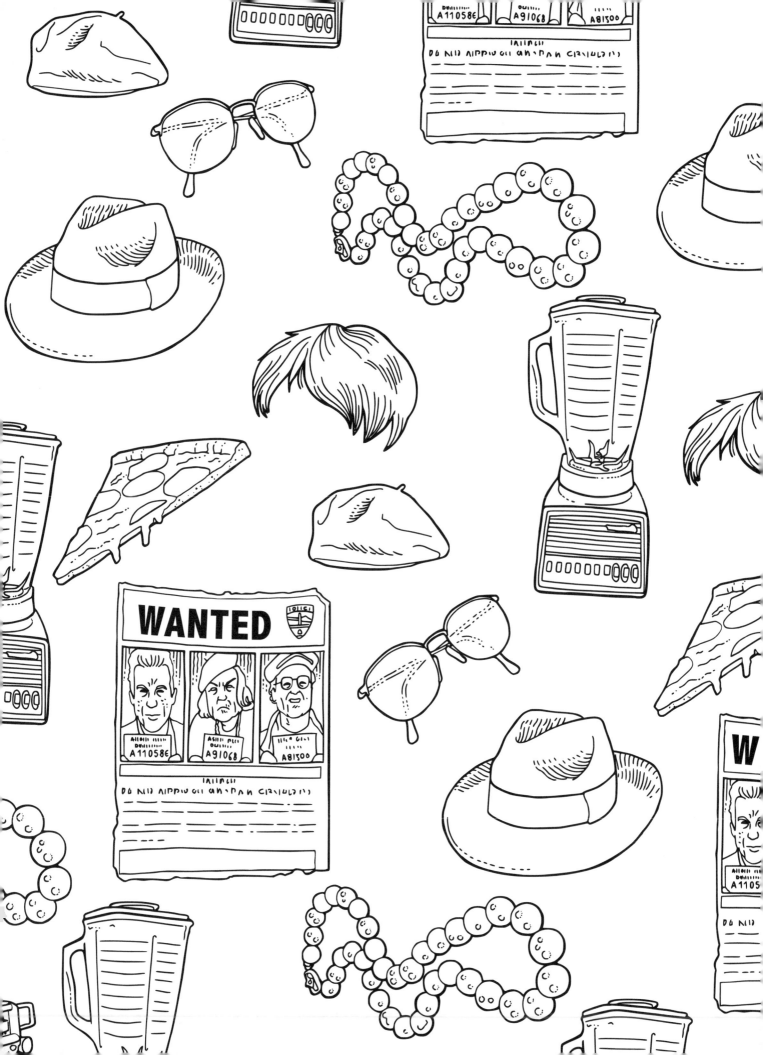

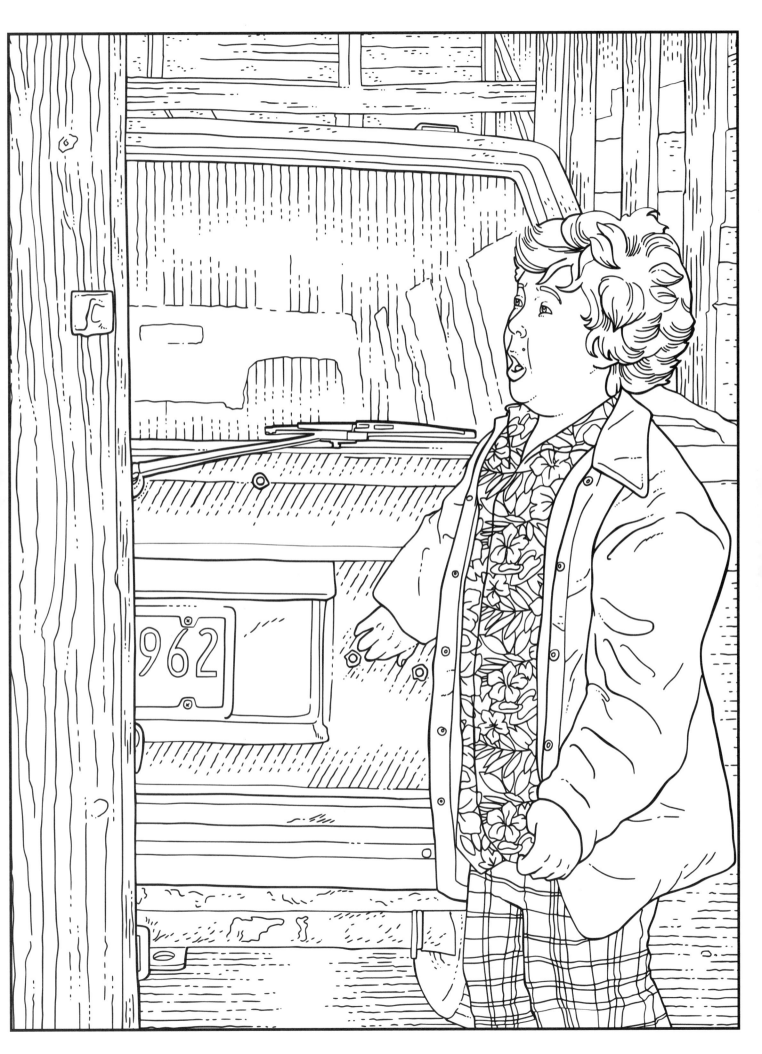

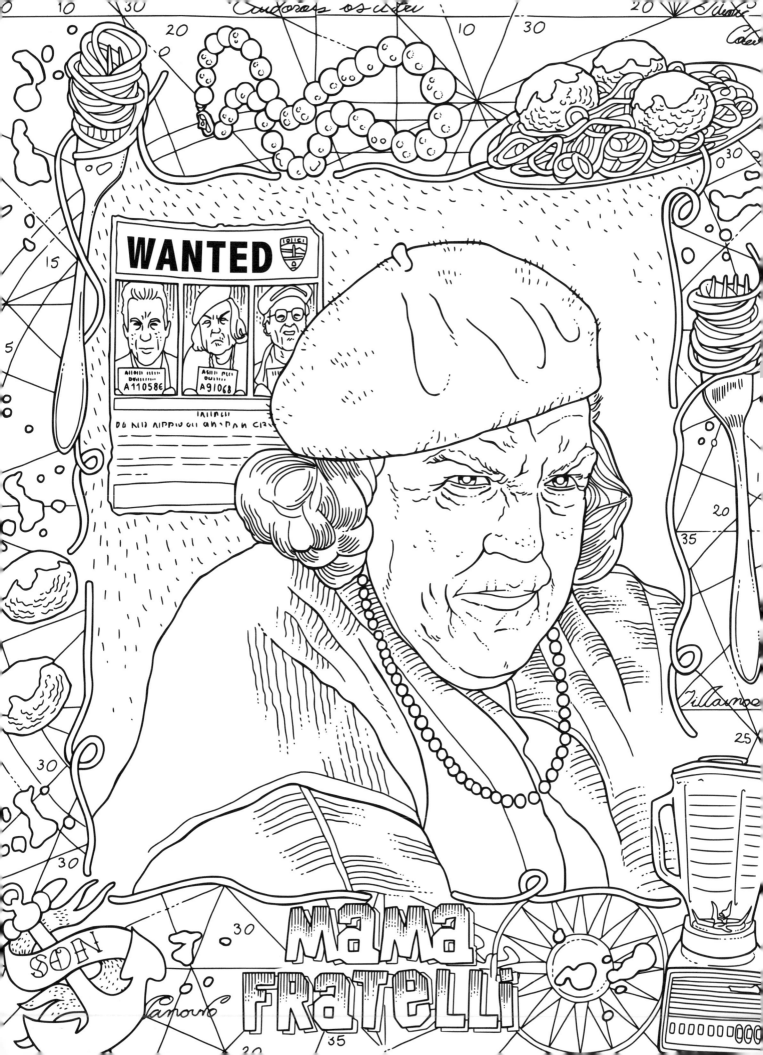

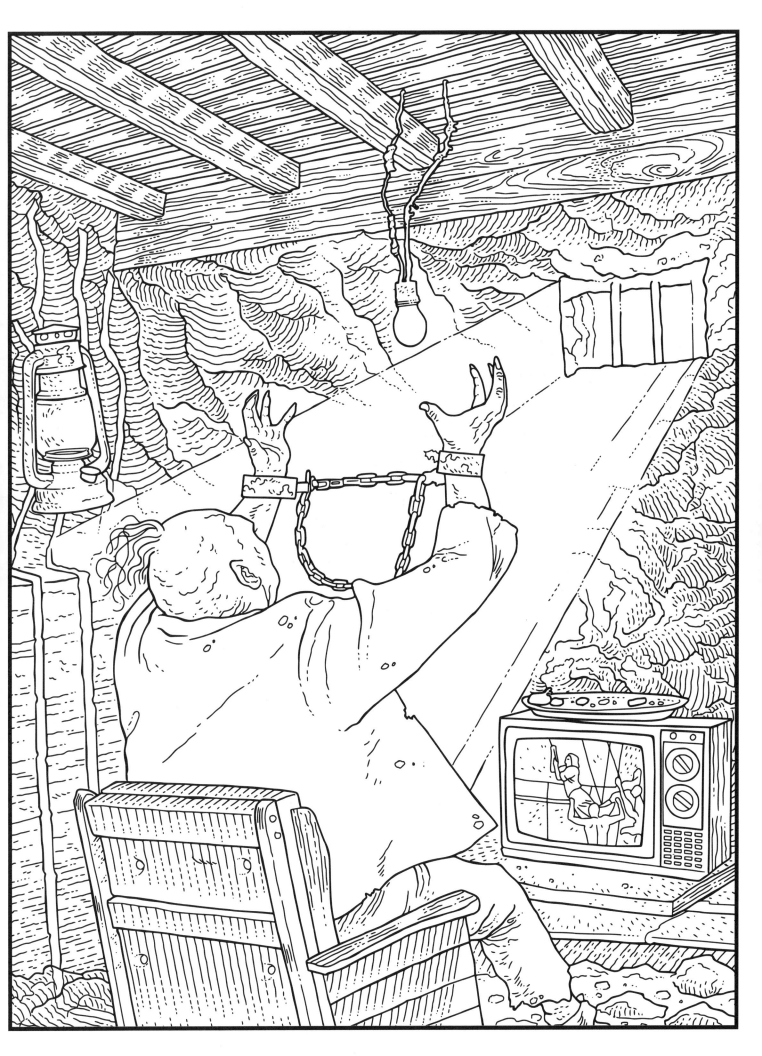

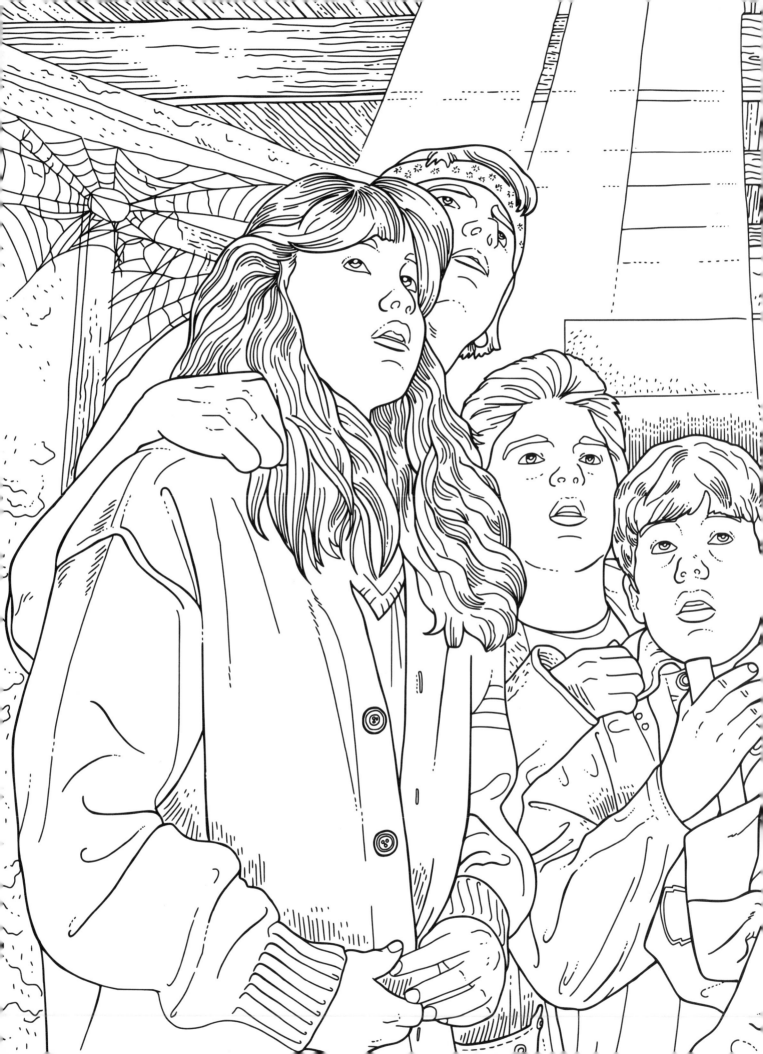

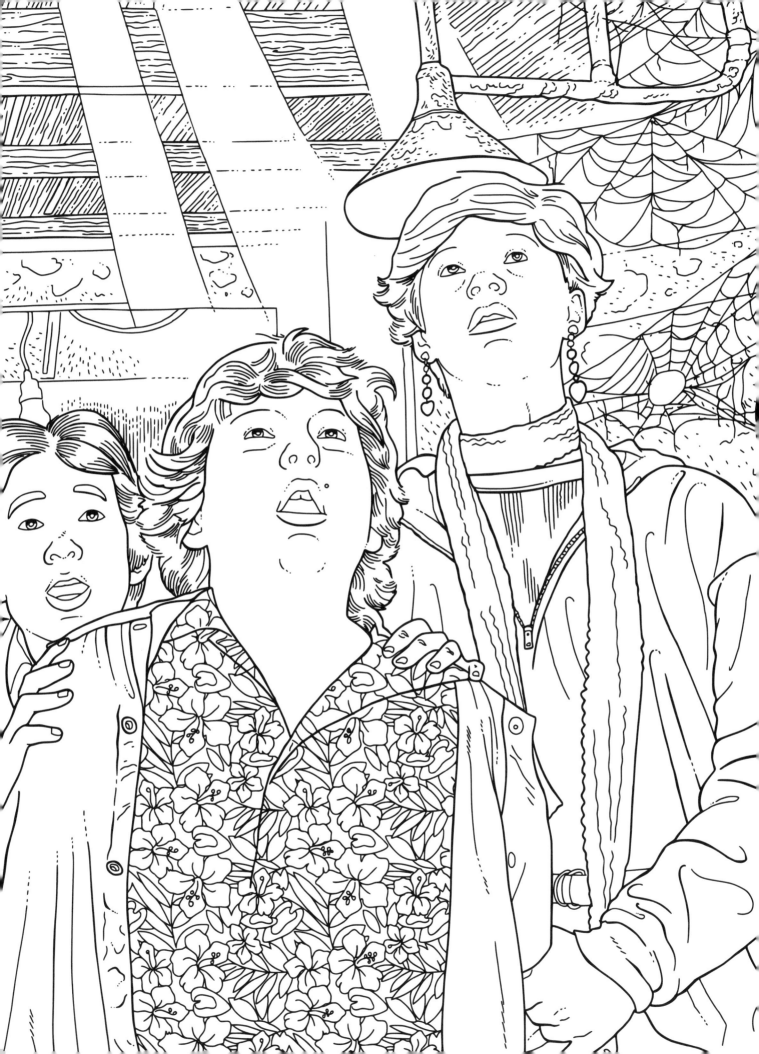

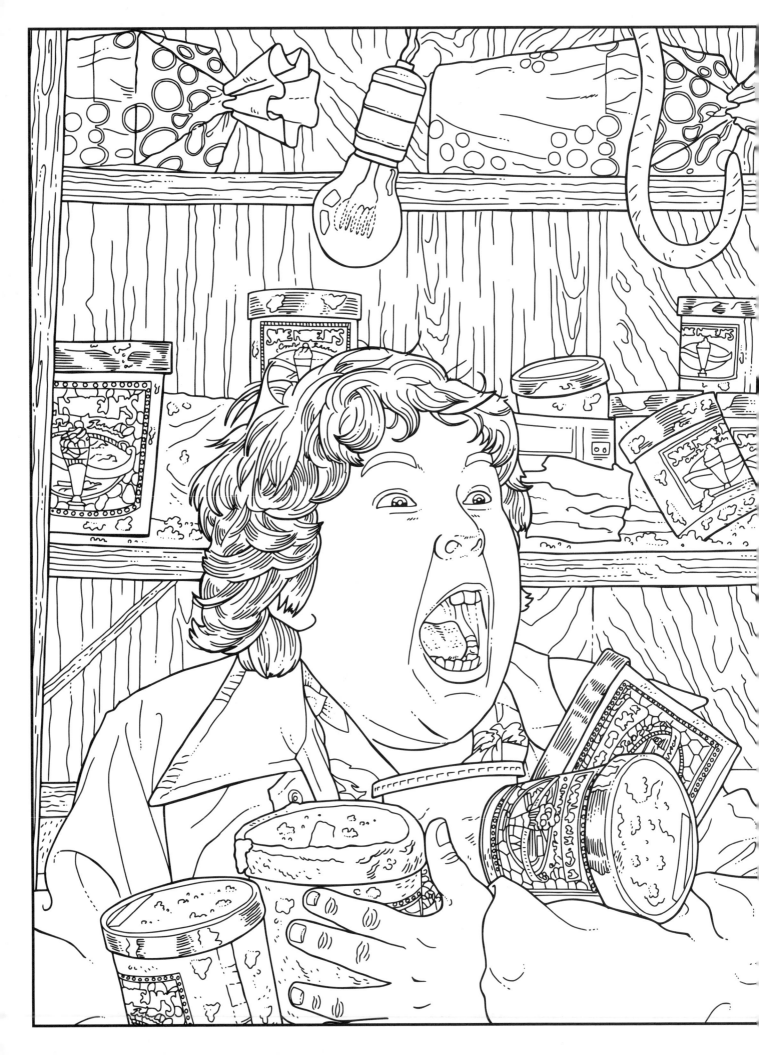

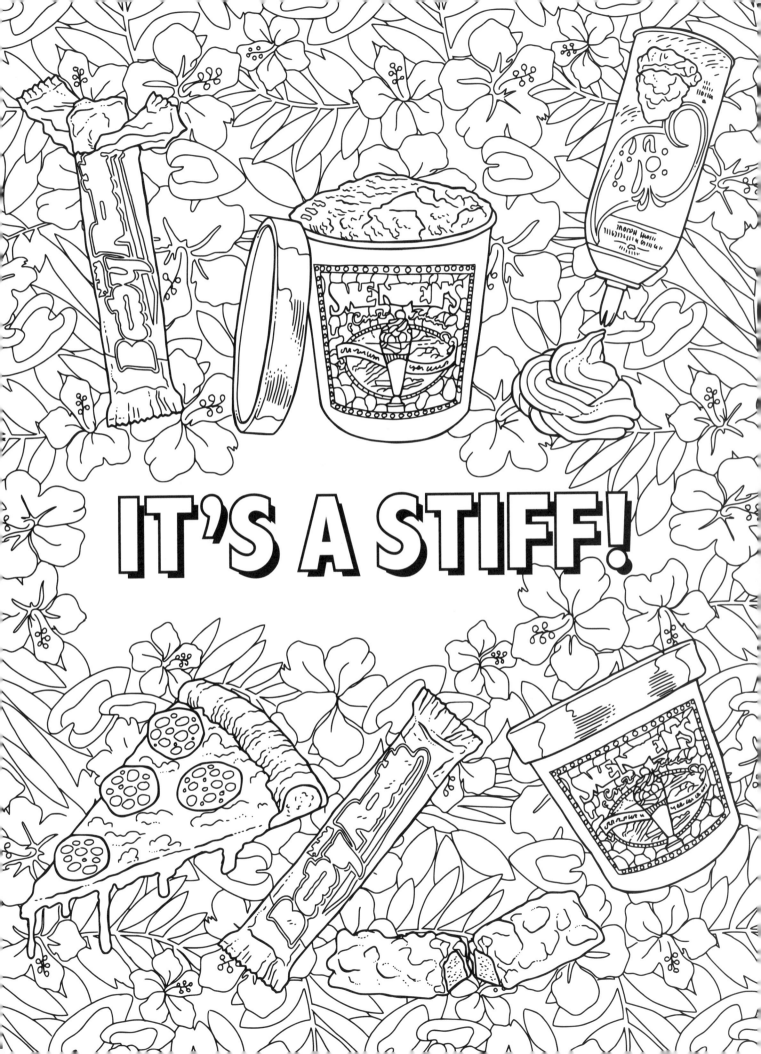

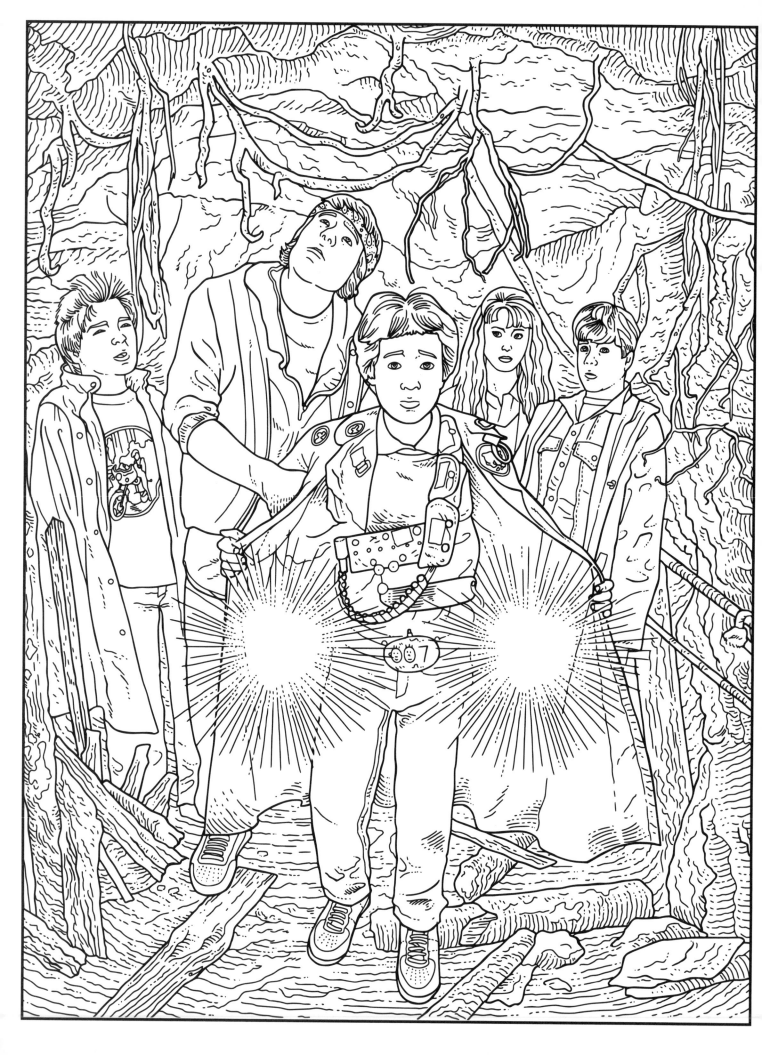

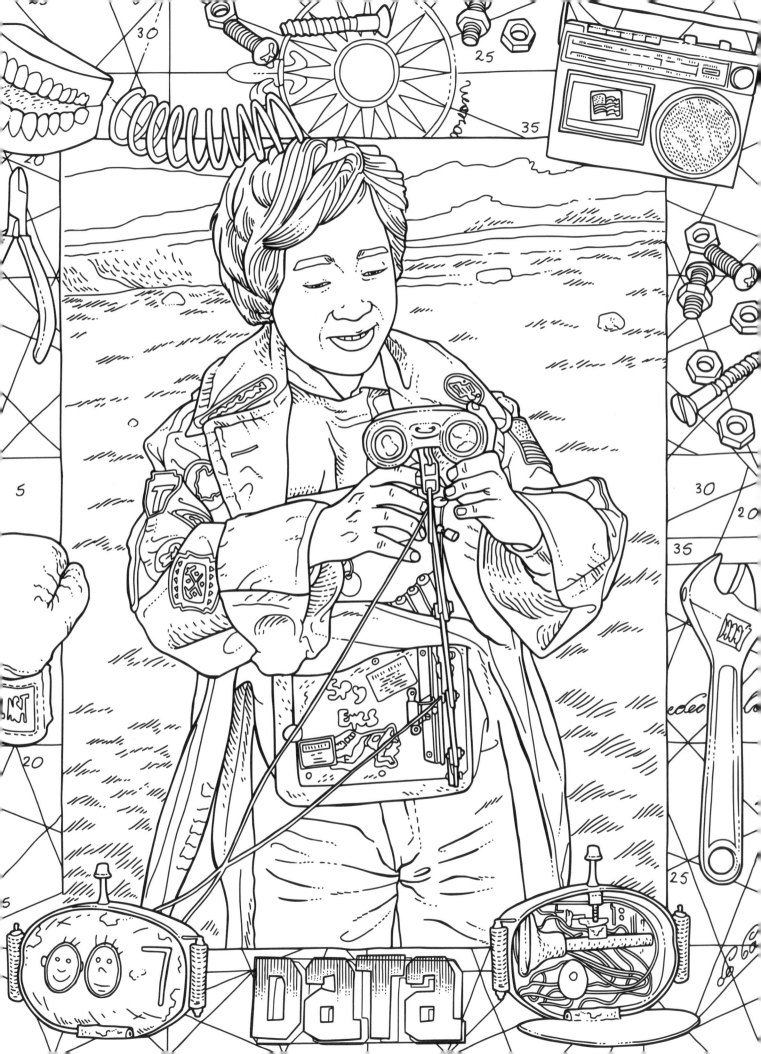

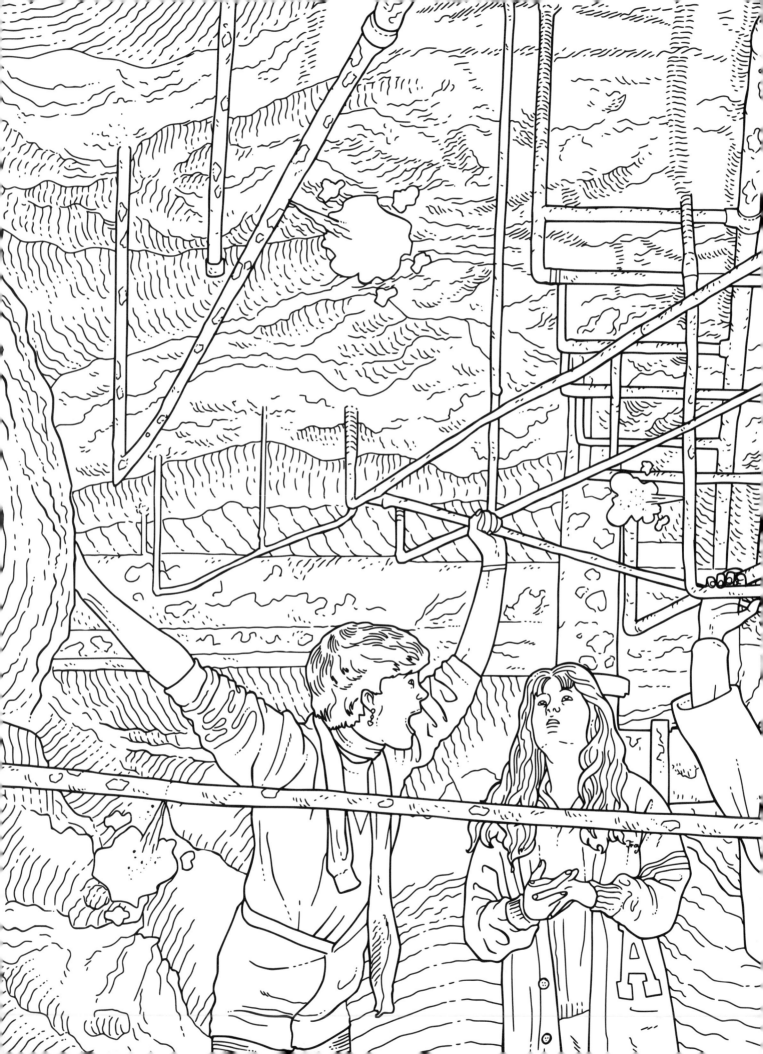

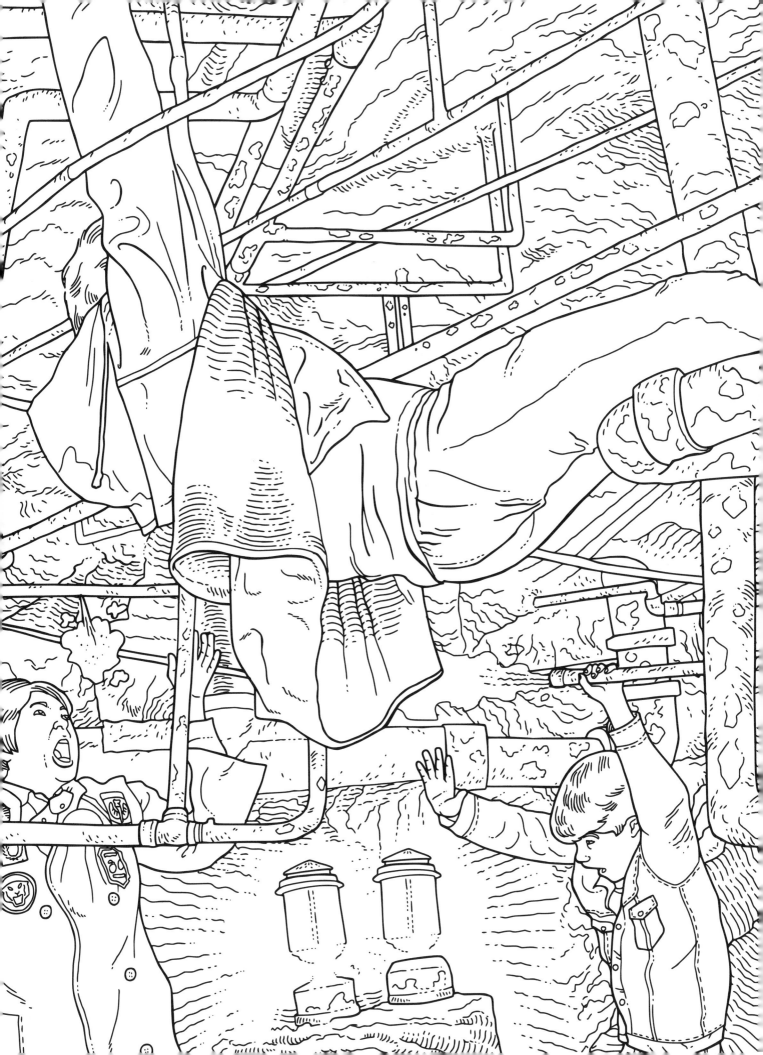

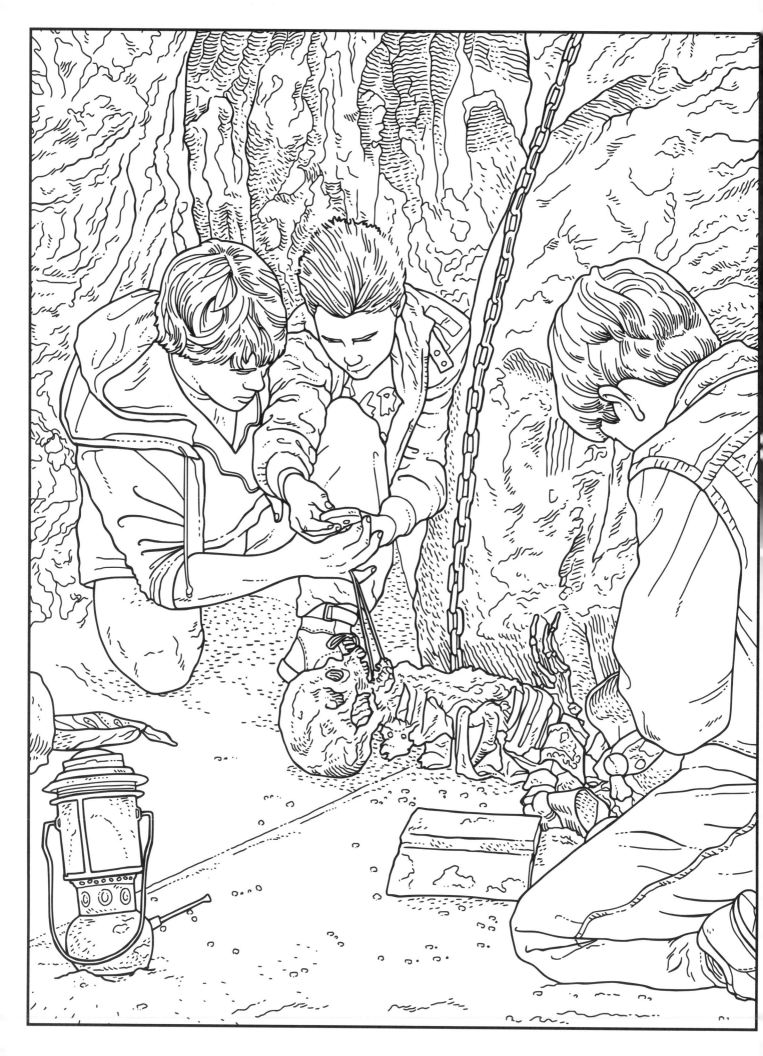

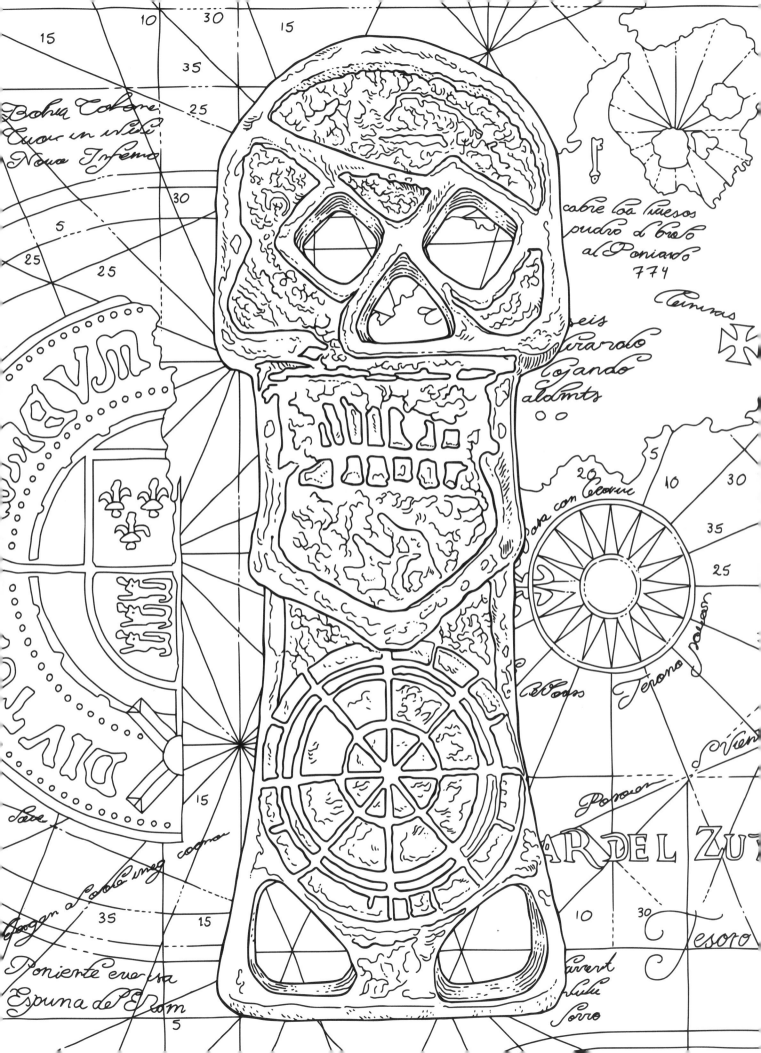

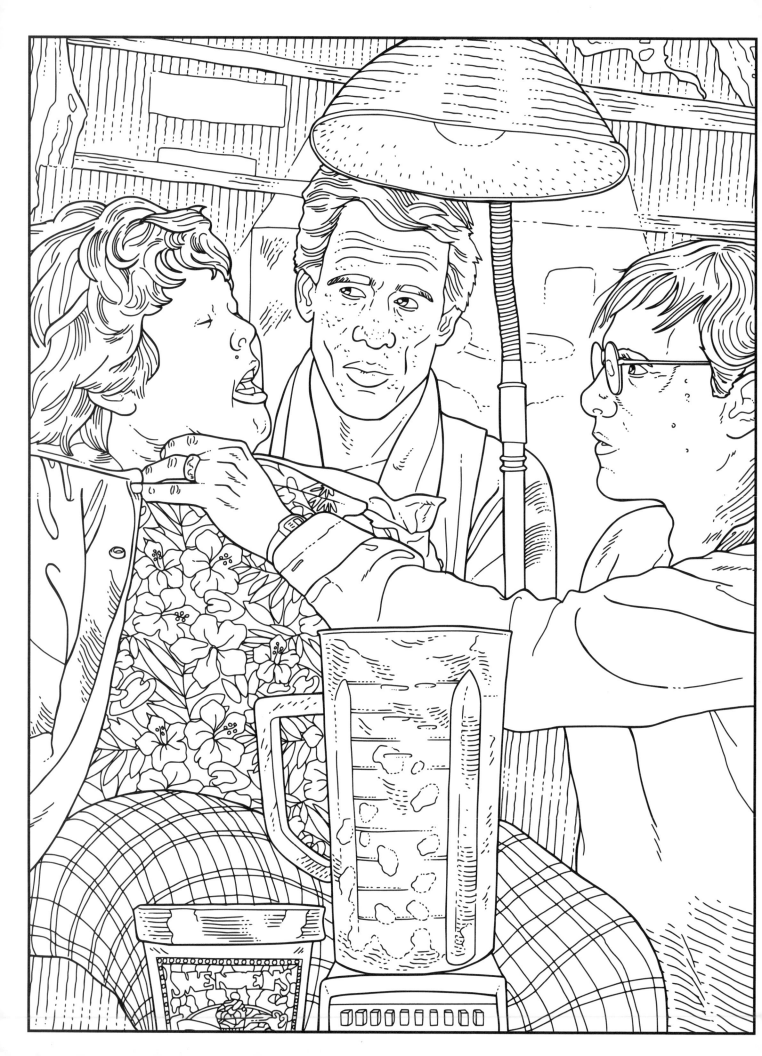

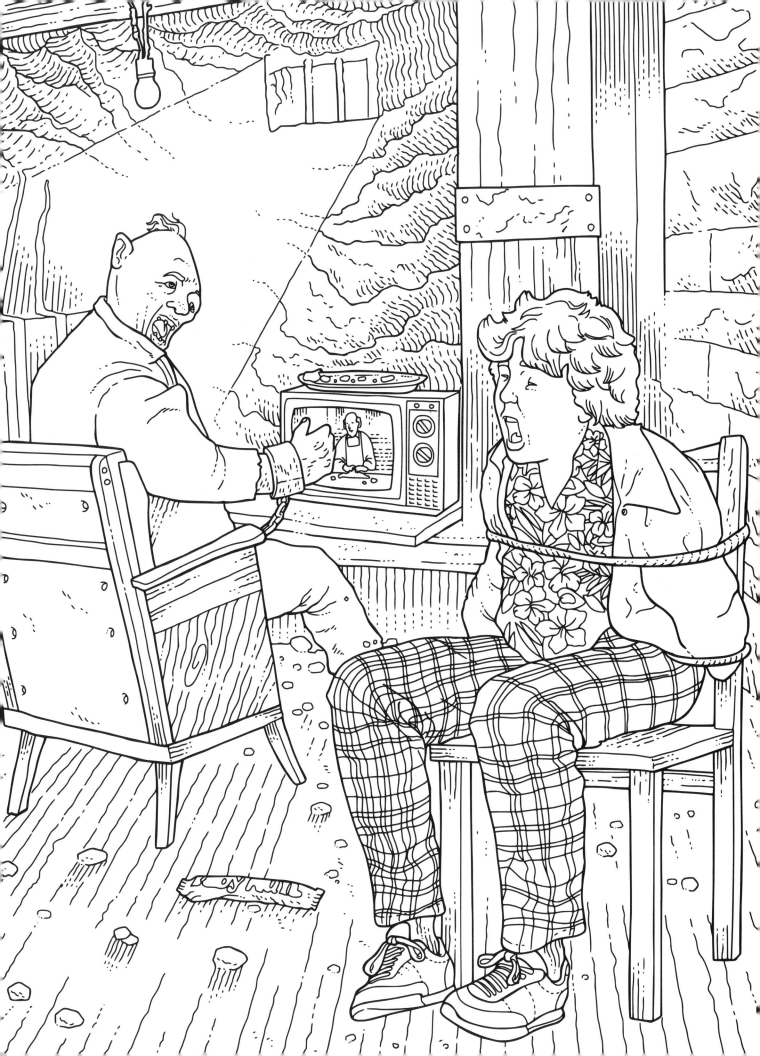

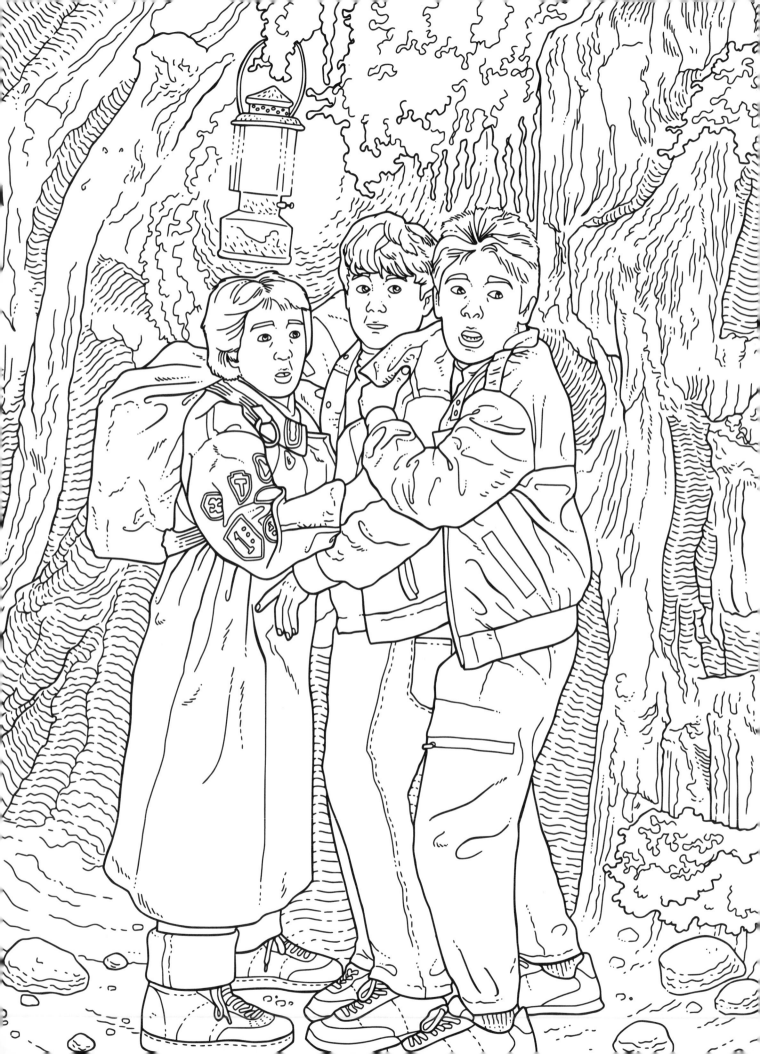

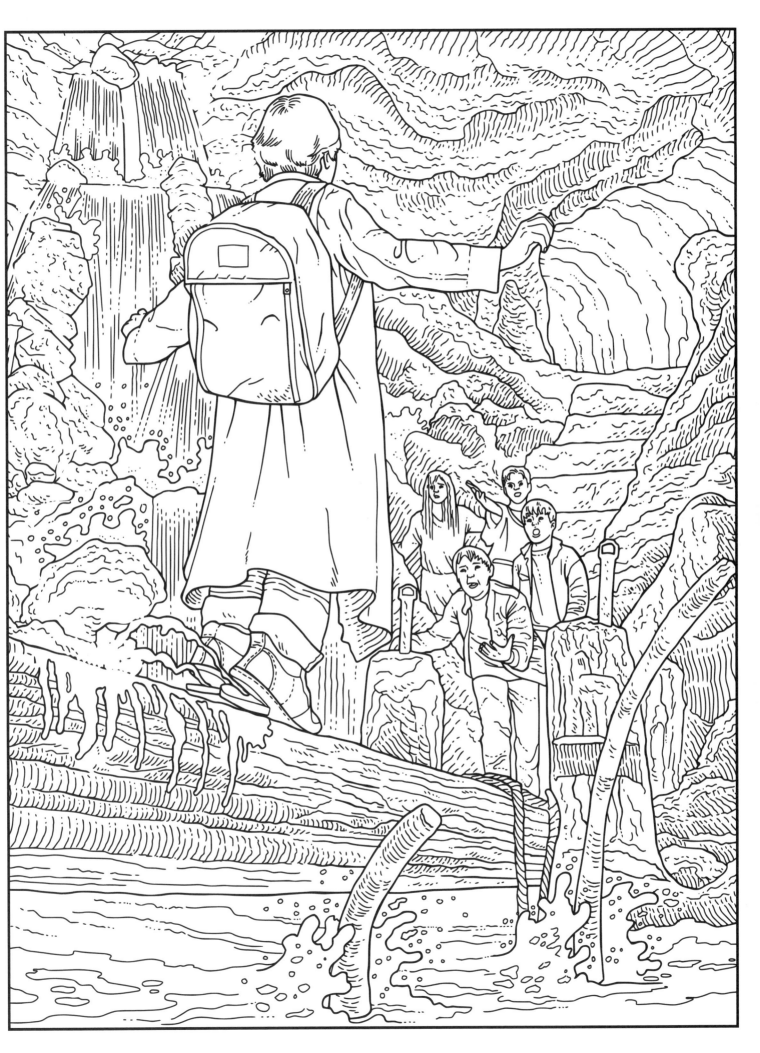

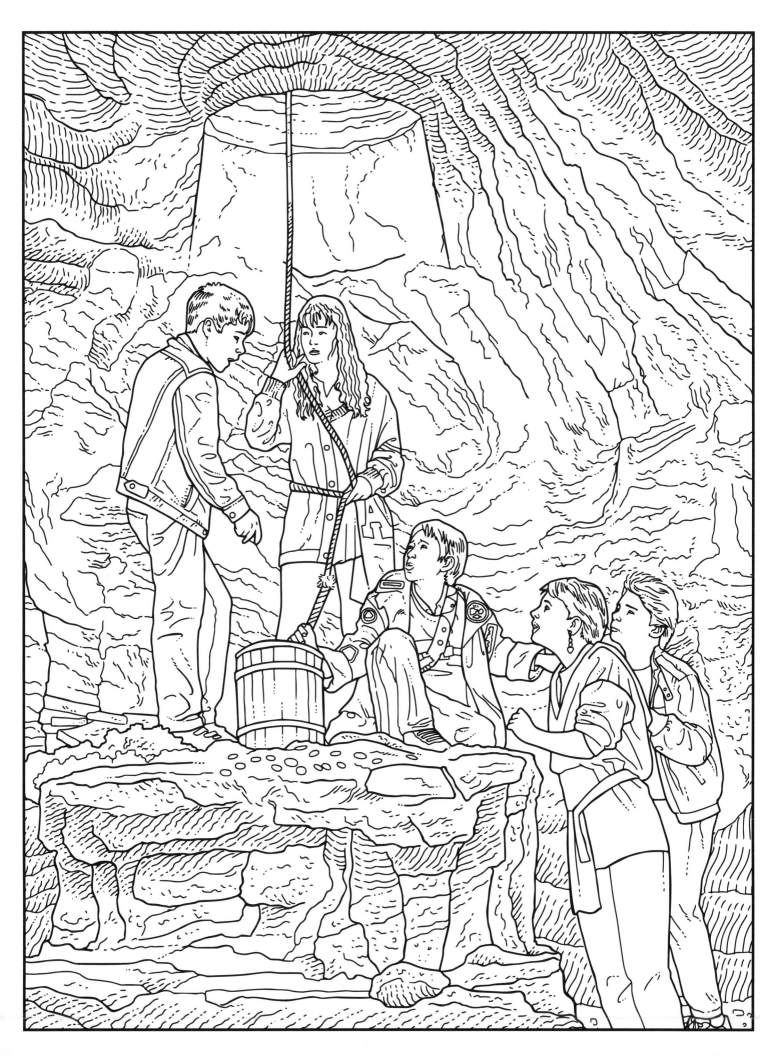

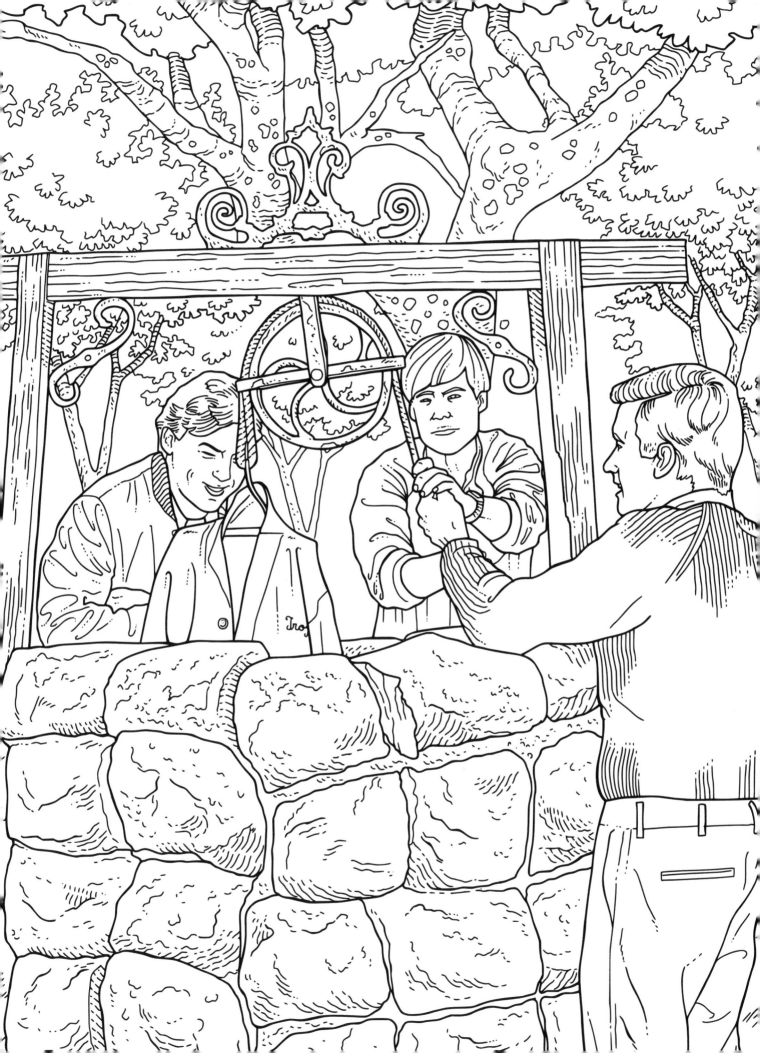

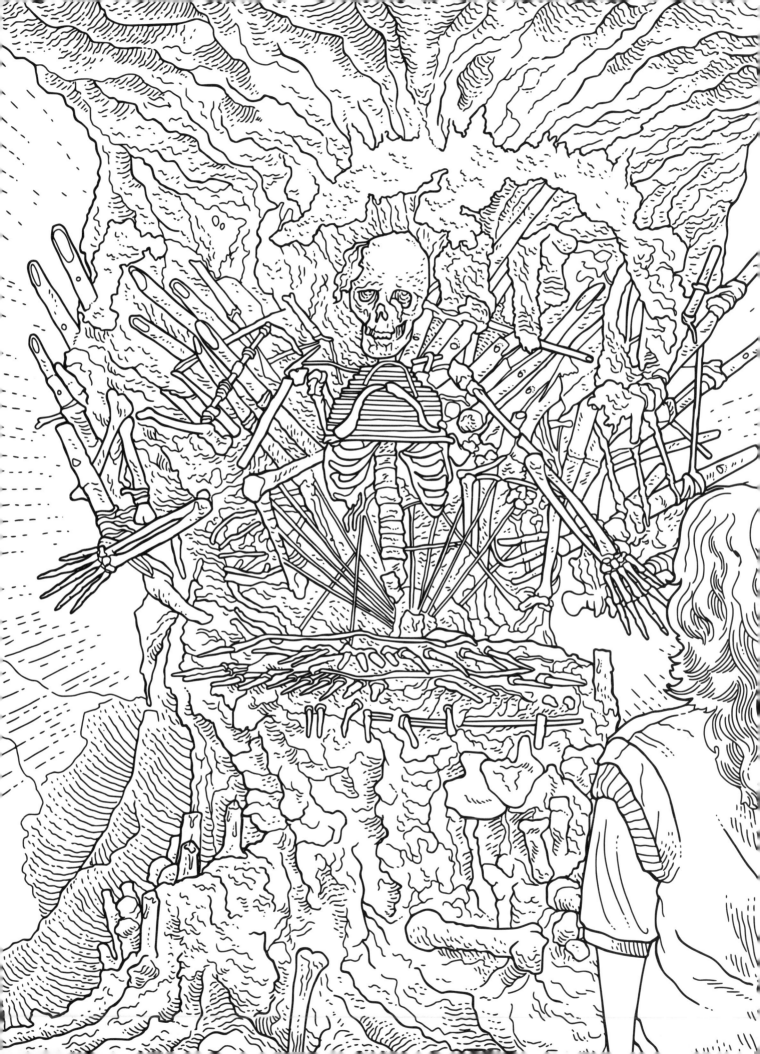

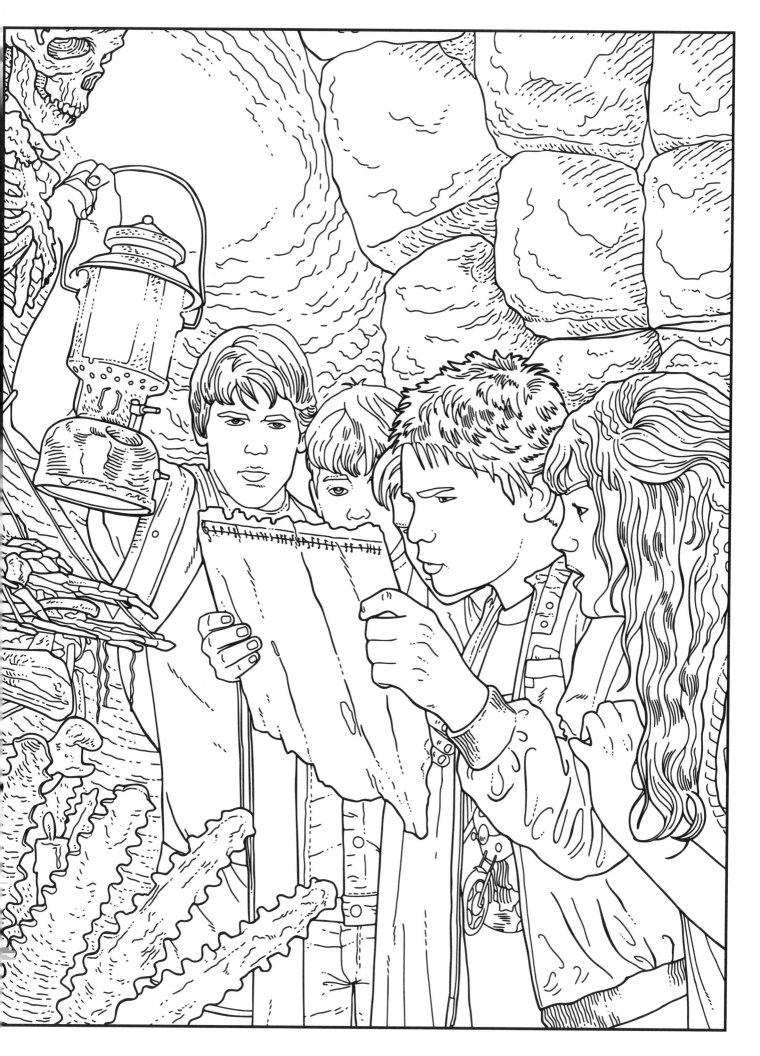

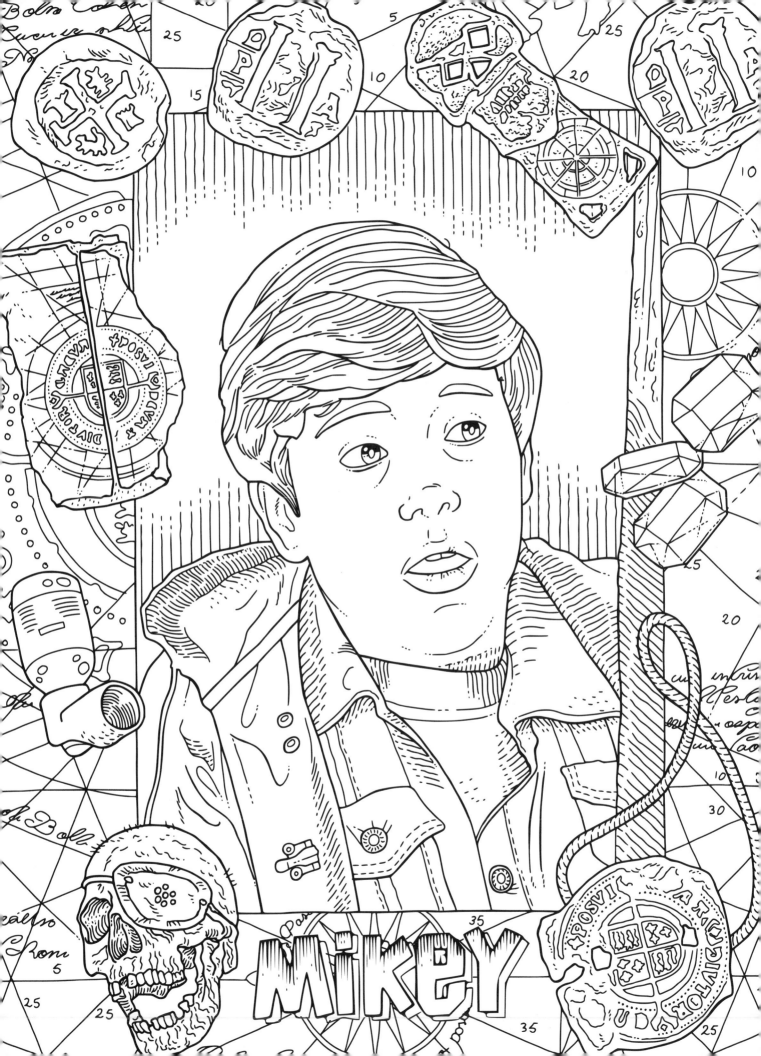

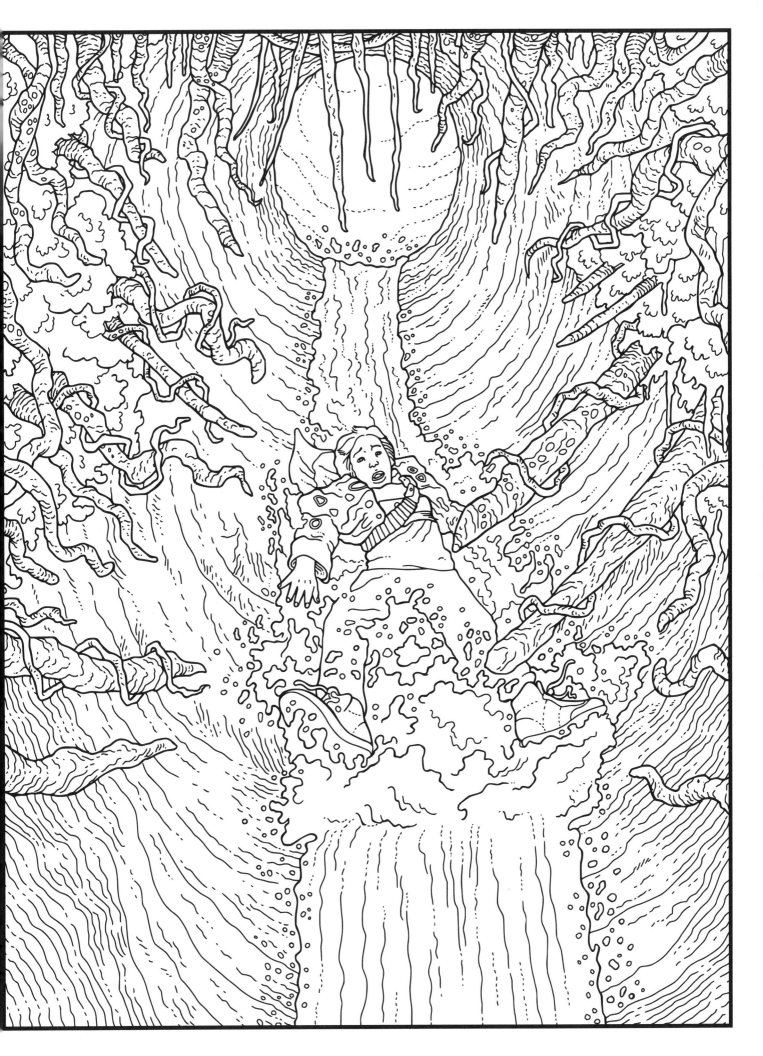

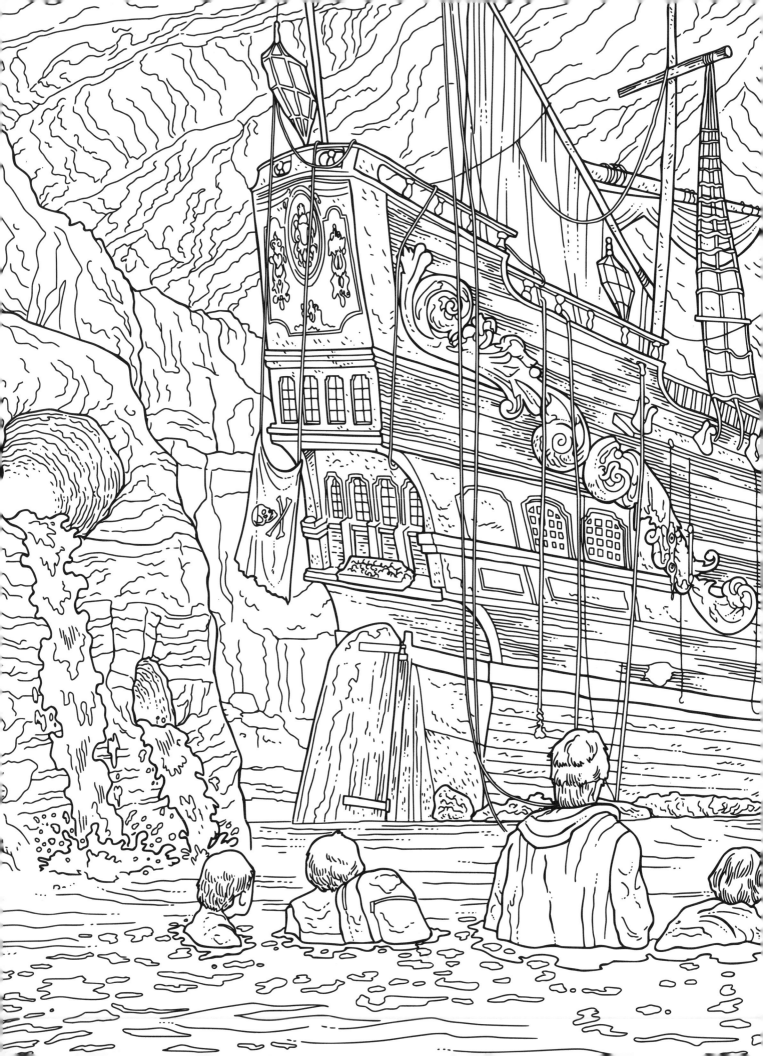

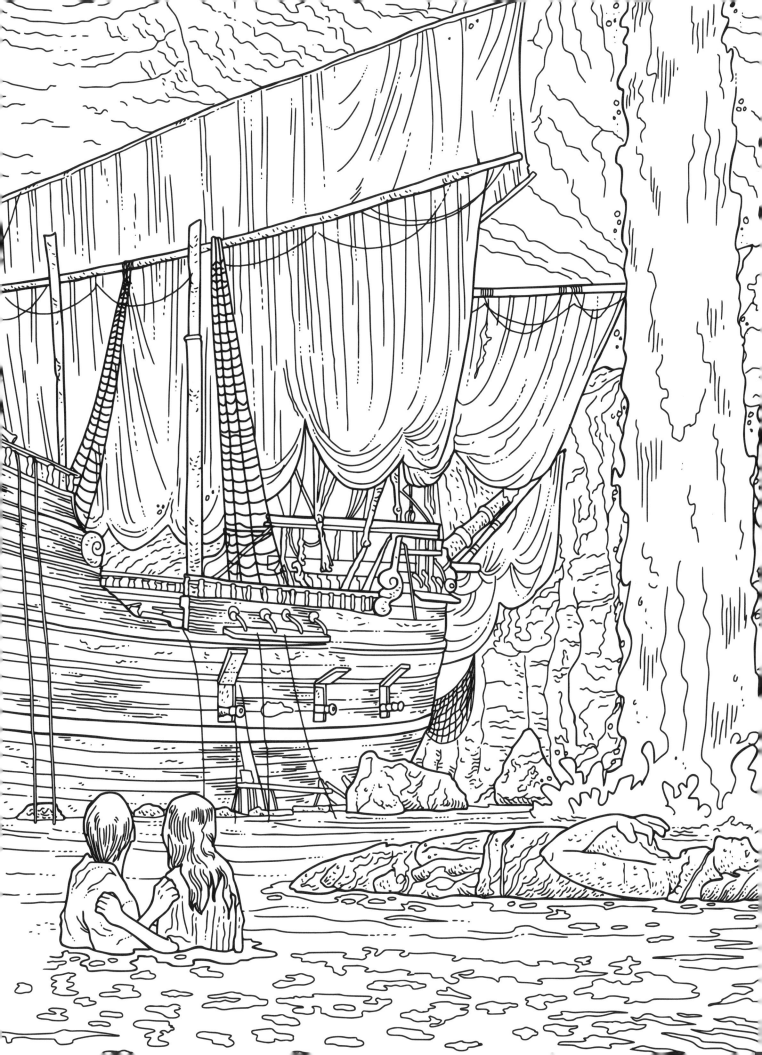

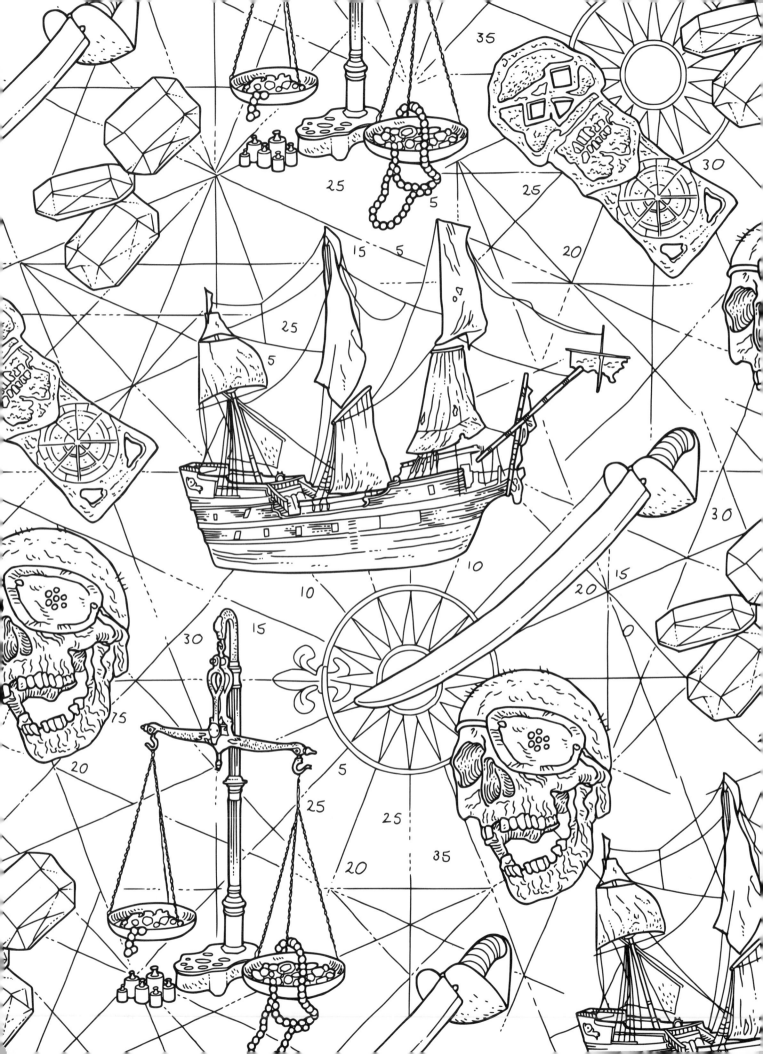

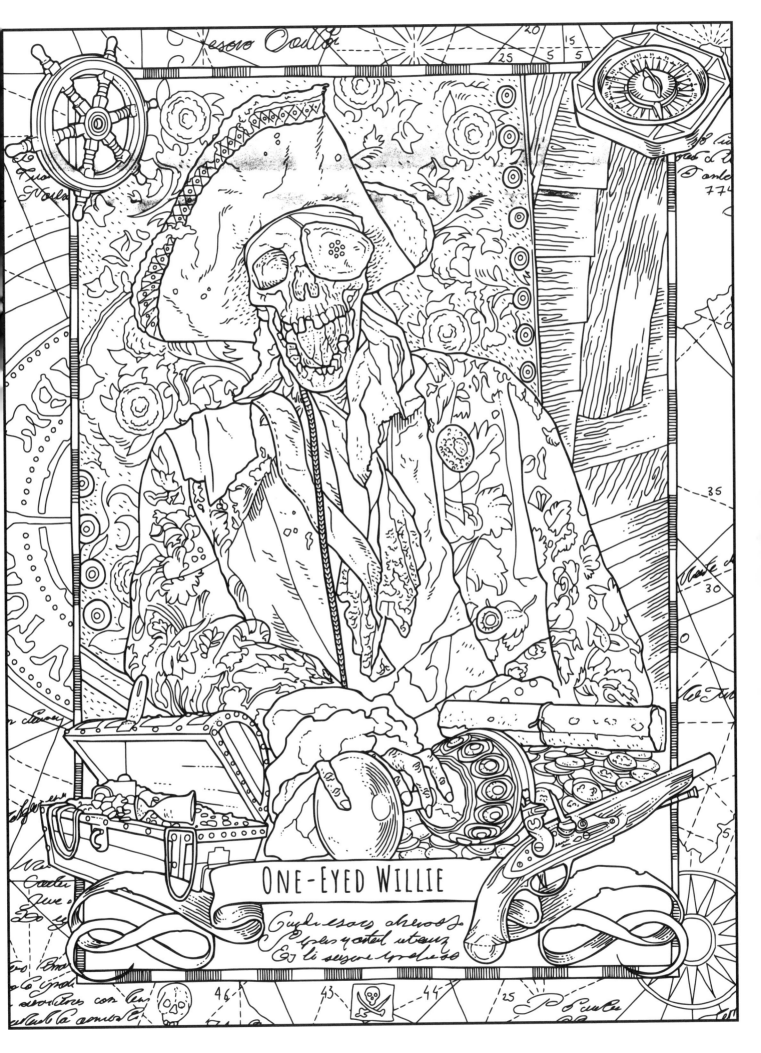

ONE-EYED WILLIE

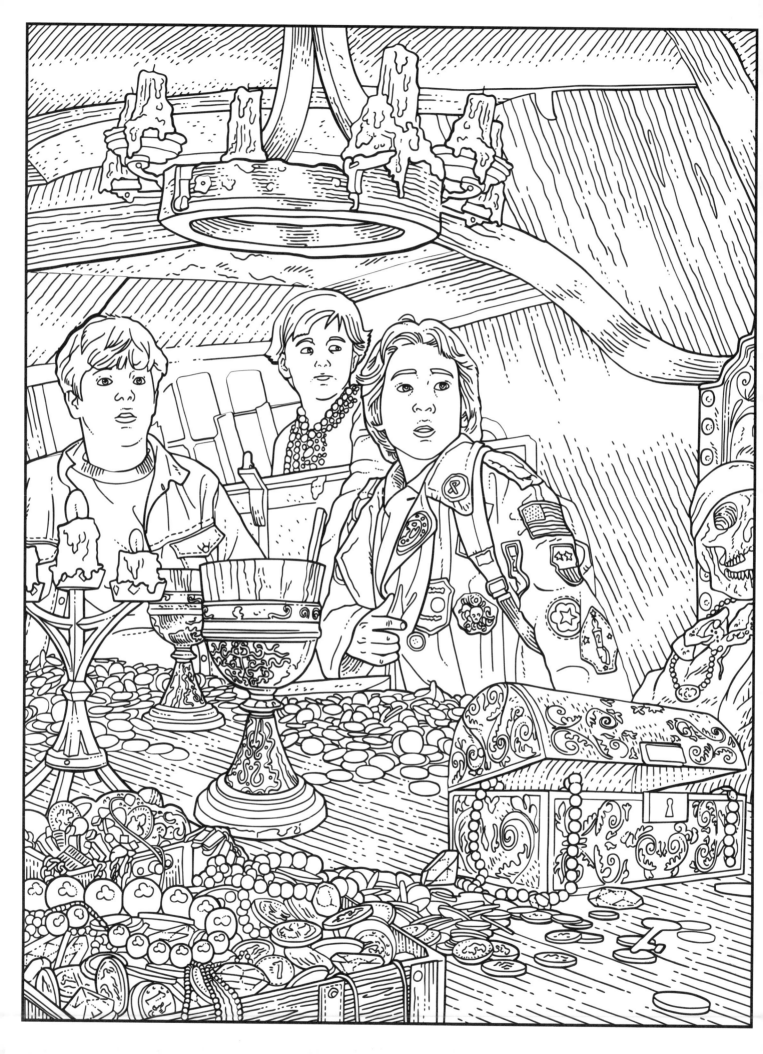

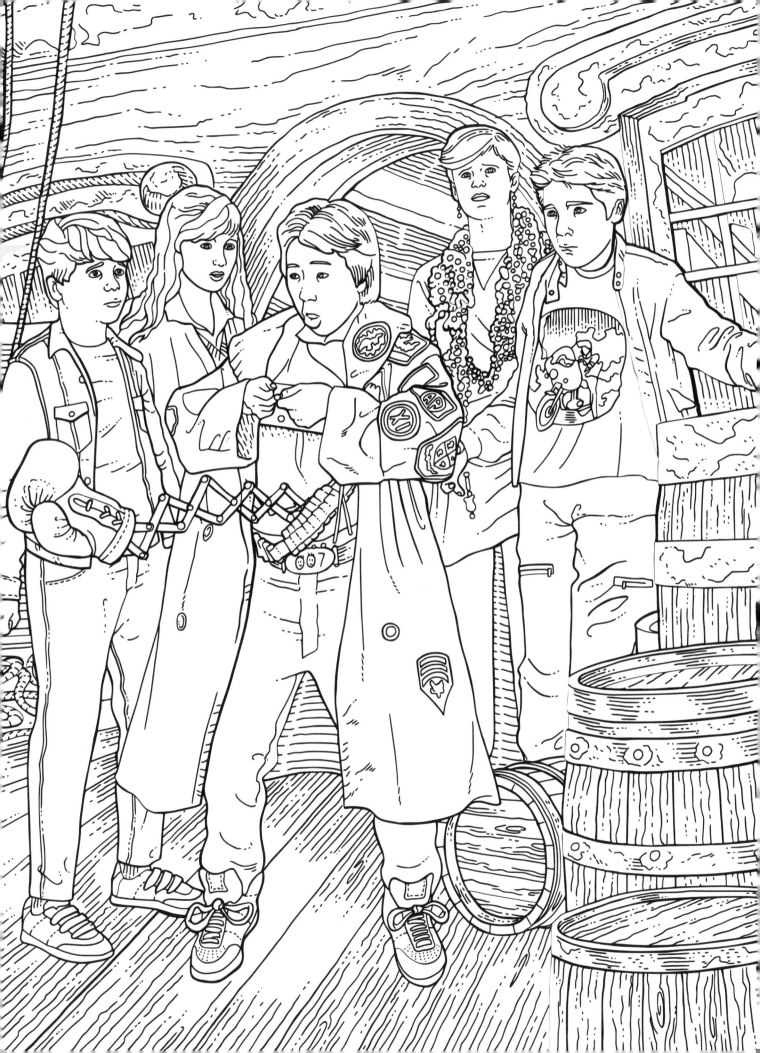

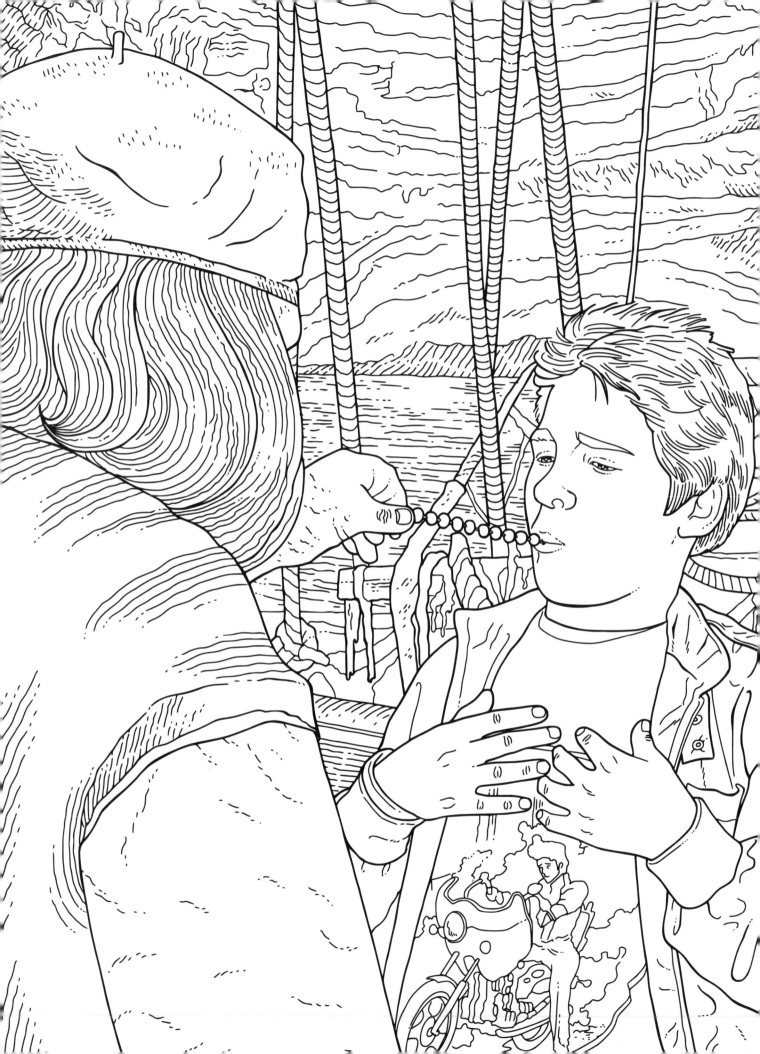

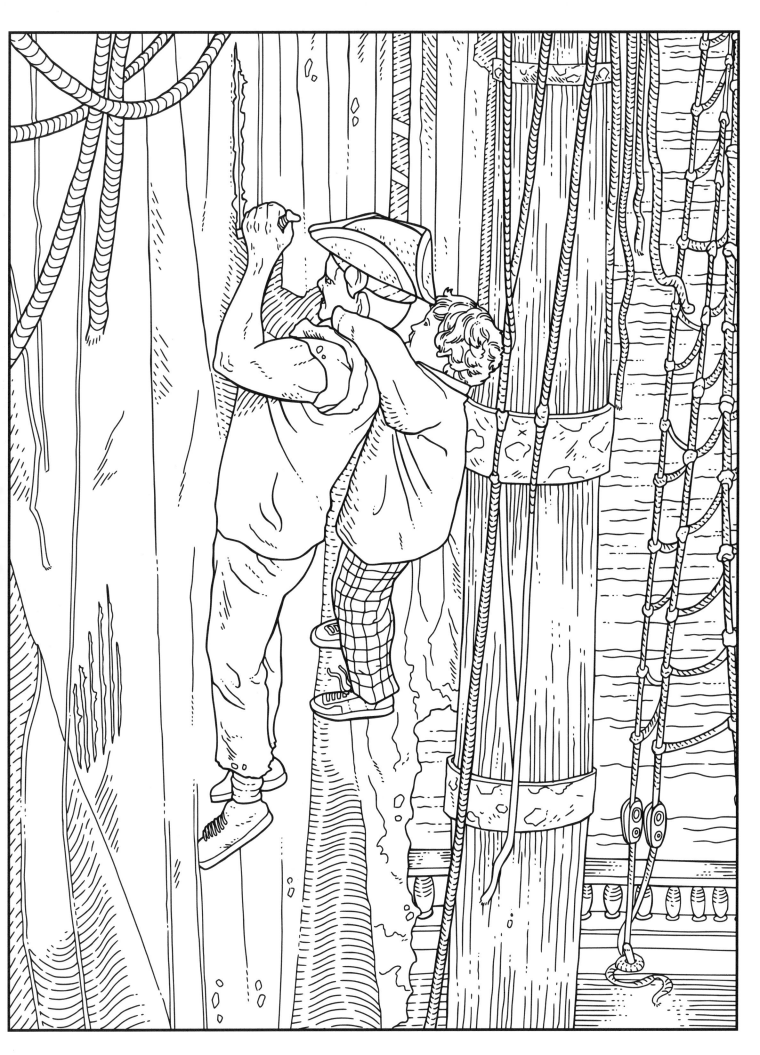

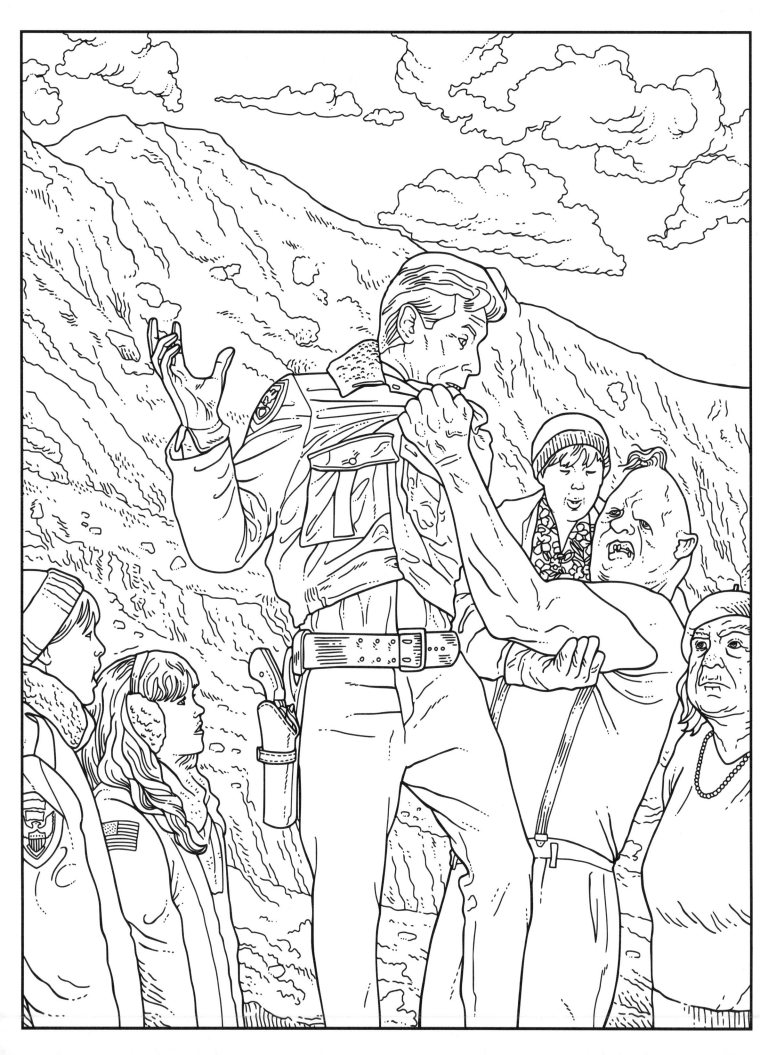

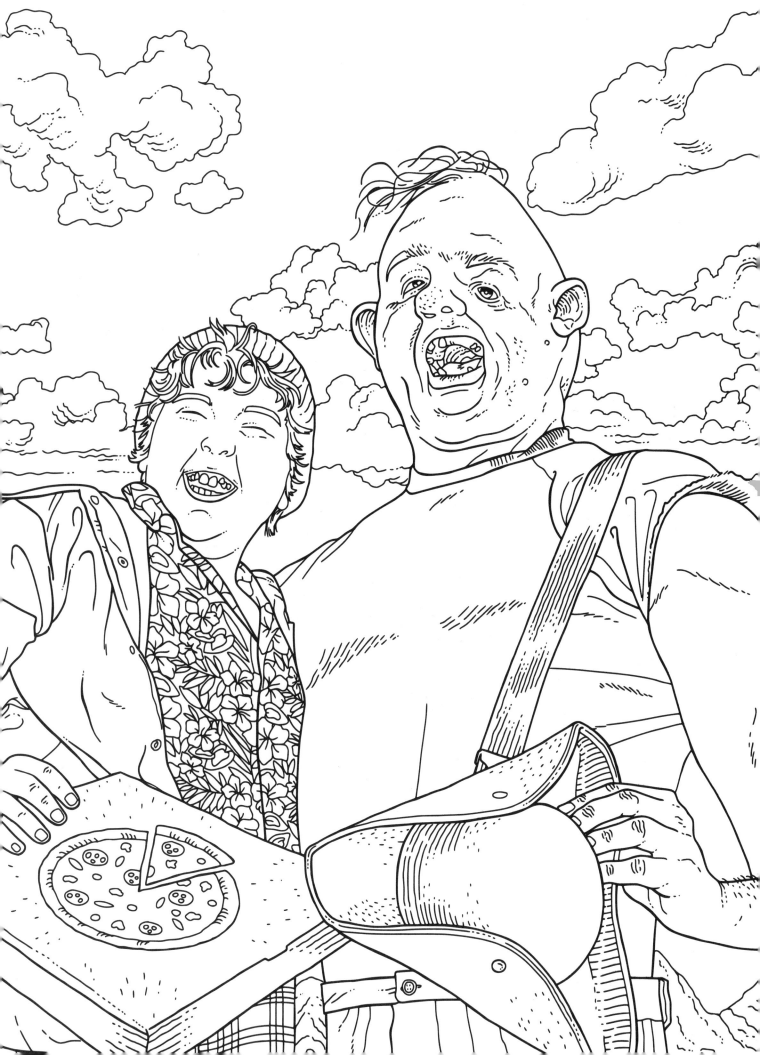

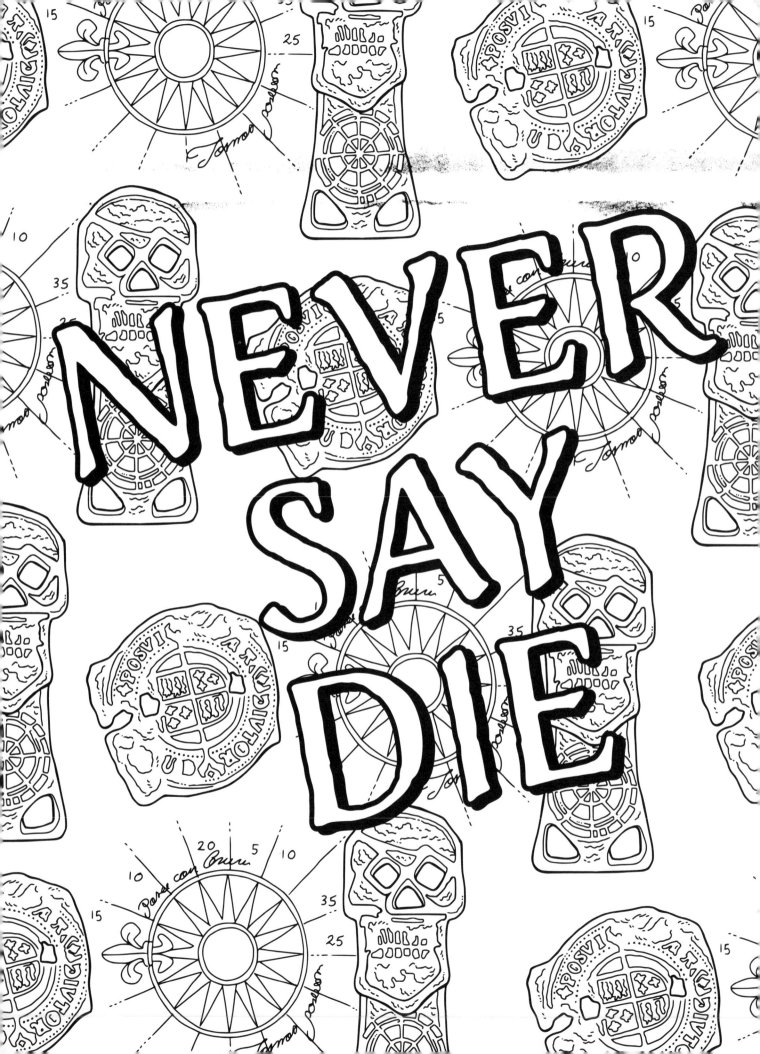

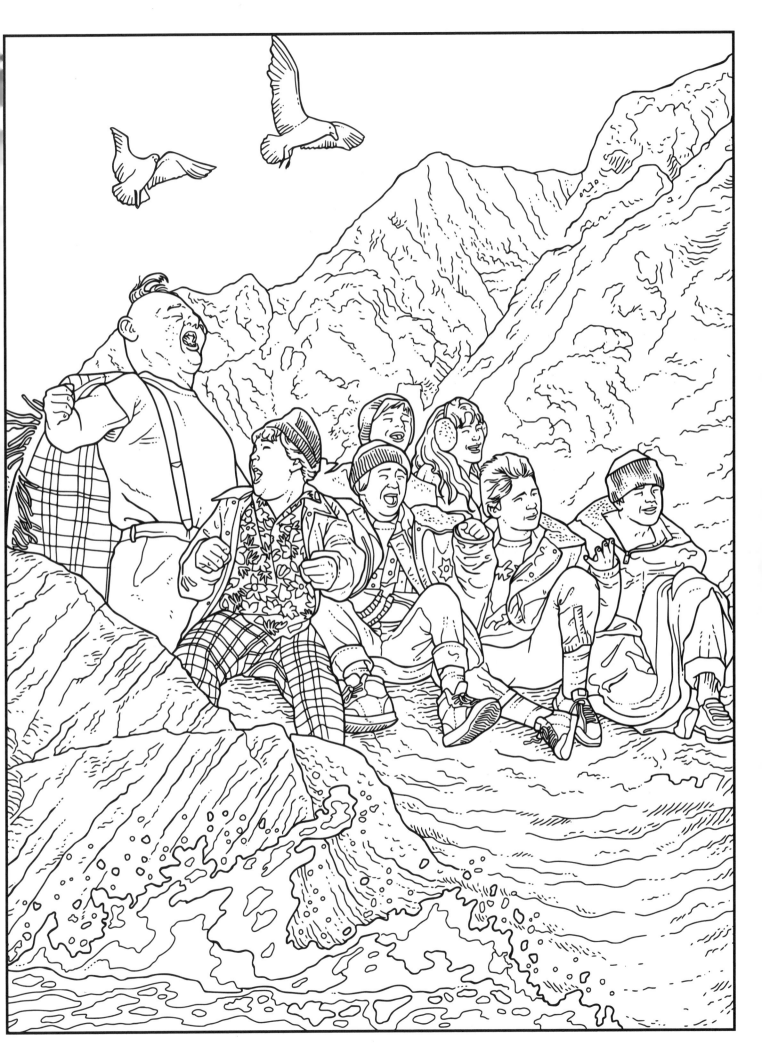

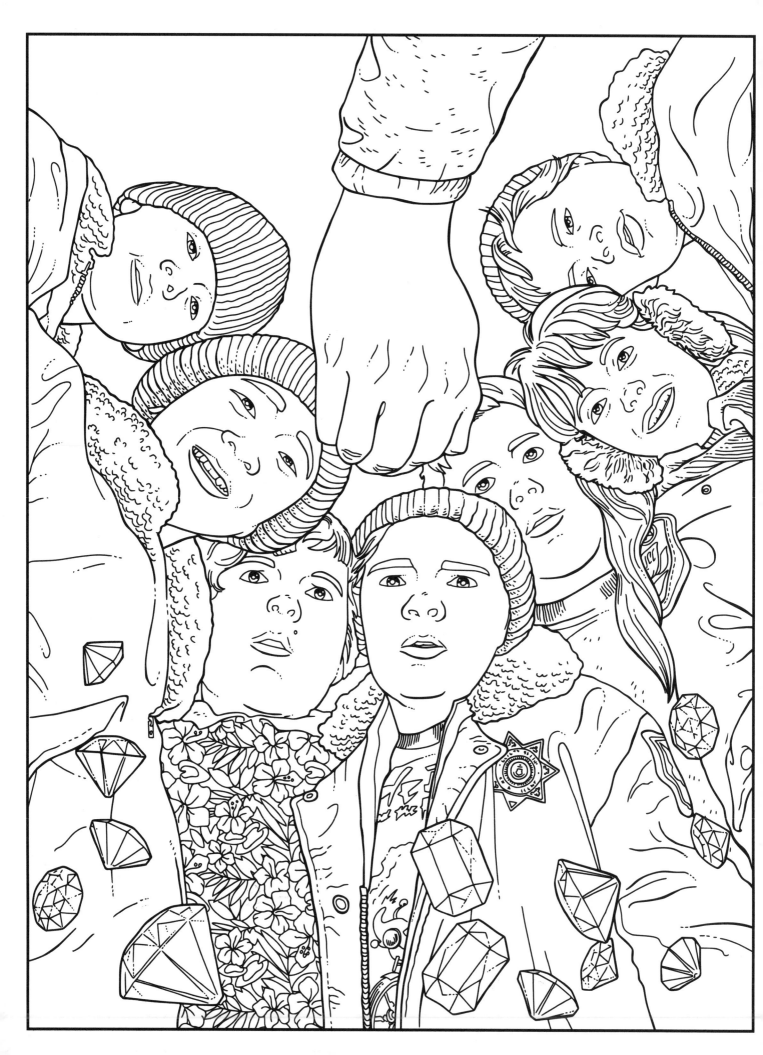

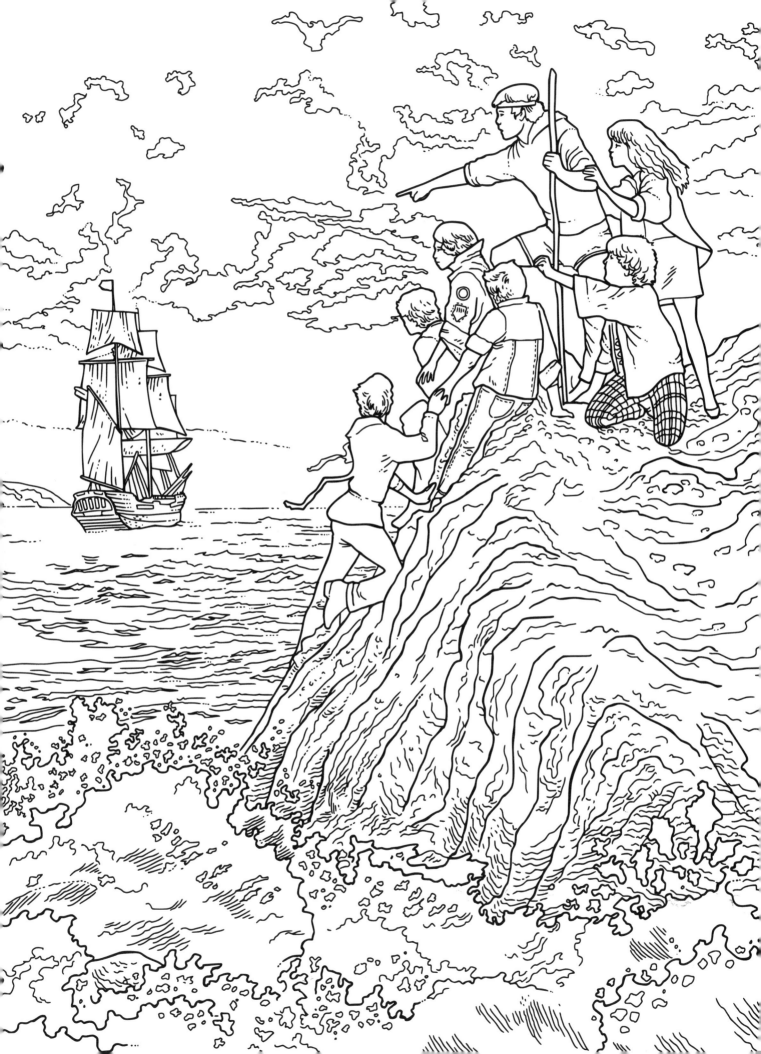

INSIGHT EDITIONS

PO Box 3088
San Rafael, CA 94912
www.insighteditions.com

Find us on Facebook: www.facebook.com/InsightEditions
Follow us on Twitter: @insighteditions

Library of Congress Cataloging-in-Publication Data available.

ISBN: 978-1-64722-196-6

Publisher: Raoul Goff
Associate Publisher: Vanessa Lopez
VP of Creative: Chrissy Kwasnik
VP of Manufacturing: Alix Nicholaeff
Associate Editor: Anna Wostenberg
Senior Production Editor: Jennifer Bentham
Senior Production Manager: Greg Steffen
Senior Designer: Judy Wiatrek Trum

Illustrations by Valentin Ramon

ROOTS of PEACE REPLANTED PAPER

Insight Editions, in association with Roots of Peace, will plant two trees for each tree used in the
manufacturing of this book. Roots of Peace is an internationally renowned humanitarian organization
dedicated to eradicating land mines worldwide and converting war-torn lands into productive farms
and wildlife habitats. Roots of Peace will plant two million fruit and nut trees in Afghanistan and
provide farmers there with the skills and support necessary for sustainable land use.

Manufactured in Turkey by Insight Editions

10 9 8 7 6 5 4 3 2 1